JOHN McQUEEN

D1401333

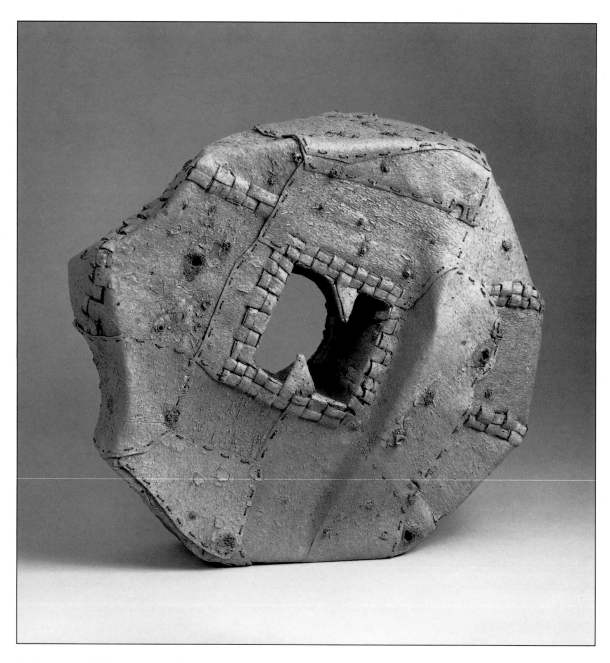

**The hole through this basket undergoes an interior
metamorphosis, starting on one side as an *N* and emerging
on the other as an *O*.**

UNTITLED #197, 1989; spruce bark; 20 × 24 × 9 in.

JOHN McQUEEN
THE LANGUAGE OF
CONTAINMENT

Essays by

VICKI HALPER

and

ED ROSSBACH

Renwick Gallery
of the National Museum of American Art
Smithsonian Institution
Washington, D.C.
in association with the
University of Washington Press
Washington and Seattle

Published on the occasion of the exhibition *John McQueen: The Language of Containment,* Renwick Gallery, National Museum of American Art, Smithsonian Institution, Washington, D.C., 20 March–5 July 1992.

First published in the United States of America by the National Museum of American Art, Smithsonian Institution, Washington, D.C. 20560, in association with University of Washington Press, P.O. Box 50096, Seattle, Washington 98145–5096

Project Director: Steve Dietz; Editor: Terence Winch; Editorial Assistant: Deborah Thomas; Designer: Wendy Byrne. Typeset by Fisher Composition, Inc., New York, New York. Printed and bound by South China Printing Company, Hong Kong.

Cover: *Untitled #203,* 1989

Page references to the works illustrated in this book are indicated in the checklist.

ISBN 0-295-97153-3
Library of Congress Catalog number 91-052928
Library of Congress Cataloging-in-Publication Data
McQueen, John, 1943–
John McQueen: the language of containment / essays by Vicki Halper, Ed Rossbach.
p. cm.
Includes bibliographical references.
ISBN 0-295-97153-3
1. McQueen, John, 1943– —Exhibitions. 2. Basket making—United States—History—20th century—Exhibitions. I. Halper, Vicki. II. Rossbach, Ed. III. Renwick Gallery, IV. title.
NK3649.55.U64M372 1991
746.41′2′092—dc20 91-52928 CIP

The National Museum of American Art, Smithsonian Institution, is dedicated to the preservation, exhibition, and study of the visual arts in America. The museum, whose publications program also includes the scholarly journal *American Art,* has extensive research resources: the databases of the Inventories of American Painting and Sculpture, several image archives, and a variety of scholarly fellowships. For more information or a catalogue of publications, write: Office of Publications, National Museum of American Art, Smithsonian Institution, Washington, D.C. 20560.

Grape vine constricts this cylinder. The clarity and simplicity of the result contradict the meticulous planning and construction of the basket: the cylinder does not just yield to a spiral squeeze; a groove is woven into a flat mat whose ends are brought together to form a plaited pipe. The groove matches the curve of a vine, previously soaked and molded into a spring.

CONTENTS

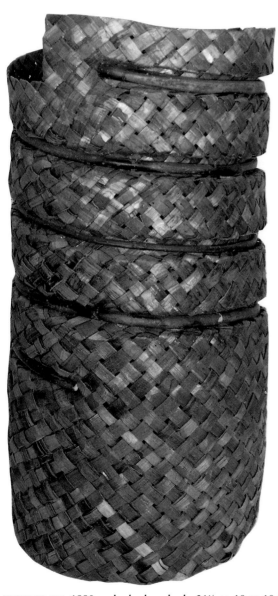

UNTITLED #94, 1980; cedar bark and ash; 21¼ × 10 × 10 in.

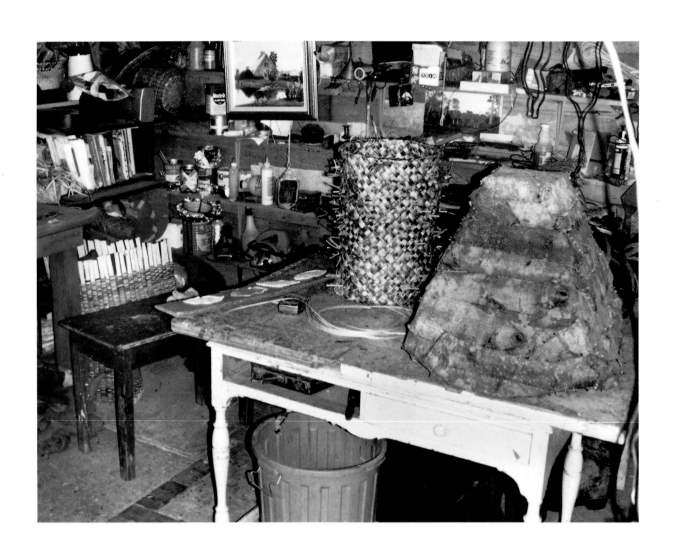

John McQueen's studio, ca. 1988.

FOREWORD

When Vicki Halper first showed me slides of John McQueen's baskets, I felt a sense of discovery, as if a secret were being shared with me. I already knew one of the works well, for the Renwick Gallery had acquired a major piece (*Untitled #121*) a couple of years earlier, and I immediately loved its evocative, organic forms and imaginative use of natural materials. But if each of McQueen's pieces is complete in its expression, taken together they constitute a new language capable of telling our most intimate concerns. His primitive materials and use of the humble art of basket-making—probably man's first form of object-making—should not belie the intensity and ambition of his art. His genius lies in finding a simple declarative means of speaking about paradox, essences, and fundamental truth. Today, when abstrac-

tion is often found insufficient to our needs, McQueen proves again that abstract form can contain our deepest thoughts.

McQueen is fortunate to have such sympathetic interpreters as Vicki Halper and Ed Rossbach. Their essays, along with the photographs in this book, reveal the secret of his mysterious objects to those able to see with the "inner eye," looking past technical ingenuity and formal experimentation into larger questions about the way we construct and shape experience. The accompanying exhibition offers the best opportunity to understand these works, which so richly reward contemplation.

ELIZABETH BROUN, Director
National Museum of American Art

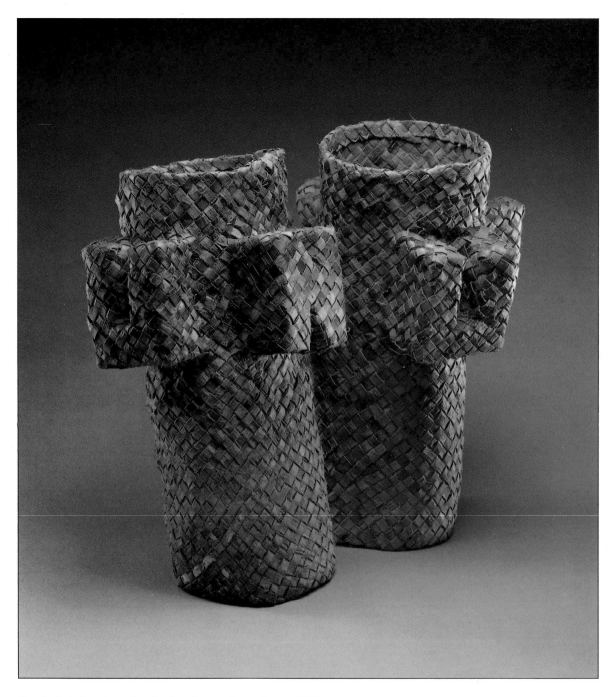

Two baskets lean toward each other. One carries the letters *UNB;*
the other *EGUN.* The word "unbegun" suggests a prehistory that is as hard
to grasp as the present moment. A related pair of communicating baskets
(not exhibited) spells "undone," suggesting post-history.

UNTITLED #150, 1987; willow bark; 18 × 18 × 12 in.

ACKNOWLEDGMENTS

John McQueen: The Language of Containment is the second of a series of monographs, published by the National Museum of American Art for its Renwick Gallery, presenting important figures in the contemporary American craft movement. This catalogue and the accompanying exhibition document the remarkable richness and diversity of John McQueen's achievements as a maker of sculptural basket forms. We hope that through these efforts new audiences will discover and enjoy McQueen's stunning objects, while those already familiar with them will gain fresh insights.

The issues of form, language, and containment have been of primary concern to John McQueen during the past two decades. One of the principal figures in contemporary American basketmaking, McQueen has created basket forms that seem intimately bound with the generating forces of nature.

Trained as a sculptor, McQueen makes baskets that are evocative, uncontrived forms marked by their strength and clarity. While the constraints of traditional materials, techniques, and construction may limit other basketmakers, McQueen uses them to fashion new forms in a way that is unparalleled in contemporary American craft. His choice of delicate materials—bark, twigs, vines, and burrs—has not hindered his ability to construct visually powerful three-dimensional containers, whose scarcely altered surfaces always remain subservient to meaning.

McQueen's vessels simultaneously reflect tradition while overturning it.

We are deeply thankful to John McQueen—a man who translates his rich life into rich works of art—for his patience, cooperation, and thoughtful responses to an abundance of demands throughout every phase of this endeavor. His help has been invaluable.

Ed Rossbach and Vicki Halper are owed a special debt of gratitude for their excellent contributions to this project. Rossbach's immediate affirmative response to our request that he contribute to the catalogue fueled the publication and lifted our spirits. We thank him for his revealing portrait of John McQueen. Vicki Halper's insightful essay eloquently discusses the meaning of McQueen's sculptural container forms. Helen Abbott and Suzanne Kotz, colleagues of Vicki Halper's in Seattle, deserve our thanks for their excellent advice.

We are extremely grateful to the James Renwick Alliance, the Renwick Gallery's support group, for its generous contribution, which enabled Vicki Halper to serve as guest curator of this exhibition. On leave from the Seattle Art Museum, Halper brought her considerable curatorial expertise to bear on our understanding of McQueen's work.

We wish to extend to our lenders a genuine sense of gratitude and appreciation, for it is their generosity that has made possible this survey of McQueen's basketwork. They are listed in the checklist section of

this catalogue. No request was refused, an indication of the depth of support for the artist and his work. We are especially grateful to Florence Duhl, Robert L. Pfannebecker, Mrs. Oscar Feldman, and Vincent Tovell for personally transporting their baskets to the photographers' studios so that the works could be documented.

For help in locating the objects, often the most difficult task in organizing an exhibition, we were fortunate to have the cheerful assistance of Wendy Jeffers, New York City; Bob and Charlotte Kornstein, Bellas Artes Gallery, Santa Fe, New Mexico; Lucette Ostergren, Executive Secretary, Museum of Modern Art, New York City; and Reid White, Princeton, New Jersey.

Special thanks go to Lloyd E. Cotsen, President and Chief Executive Officer, and to Karyn Zarubica, Curator of the Collections, Neutrogena Corporation, Los Angeles; and to Judith Calamandrei, Registrar at the Fisher Brothers Collection, New York City.

Several individuals are to be commended for their willingness to help in our efforts to find photography of objects or to assist in having new images made: Kelly D. Mitchell, Special Assistant for Contemporary Crafts, Philadelphia Museum of Art; Eric R. Johnson, John Michael Kohler Arts Center, Sheboygan, Wisconsin; and Maia Sutnik, Art Gallery of Ontario.

My colleagues at the Renwick Gallery and the National Museum of American Art greatly eased the tasks of organizing the exhibition and publication. Ellen M. Myette's superb attention to a myriad of details for the exhibition and publication was exemplary in every way. Anne Holman provided clerical and administrative support, and Gary Wright compiled slides and helped prepare manuscripts for editing.

The publication of this catalogue drew on the skills and expertise of a number of people, in particular, Steve Dietz, NMAA Chief of Publications, whose idea it was to begin a series of monographs devoted to stellar American craftsmen, and Terence Winch, Senior Editor, for his patience, diligence, and thoughtful editing.

Melissa Kroning, Chief of Registration and Collections Management, and Michael Smallwood, Assistant Registrar, ensured the safety of the works from arrival through installation; Alison H. Fenn and Kathleen McCleery provided cheerful, tactful persistence in bringing clarity to the organizational process. Allan Kaneshiro's sensitive installation design reinforced the strength and drama of McQueen's baskets.

Wendy Byrne, the catalogue designer, brought to this publication a clarity that enhances our ability to appreciate the complexity of John McQueen's basket forms.

Without question, we owe our greatest thanks to John McQueen for creating these remarkable three-dimensional forms, which have defined and redefined the history of contemporary basketmaking in America.

MICHAEL W. MONROE, Curator-in-Charge
Renwick Gallery

PREFACE

By calling his works baskets, John McQueen made a generous gift to the world of crafts. Concurrently he deprived those in the world of fine arts, who often respond only to the appellation sculpture, of a vision comparable to that of Martin Puryear or Jackie Windsor, among others. Semantics, then, have affected the galleries, museums, critics, and public that have encountered objects by McQueen.

The artist found that his desire to explore the nature of containment was best served by identification with basketmakers rather than sculptors. The anti-institutionalism of the 1960s—which fostered conceptual art, earth art, and body art, art that paid homage to the third world, cheap art, and art made of rubber, wax, or grass—laid the groundwork.

By the seventies, an artist like McQueen, who began as a sculptor, who loved natural materials, who didn't care for bombast and had no sense of greed, could—under the spell of native Indian art and the writing of Ed Rossbach—decide to make baskets.

McQueen's decision wasn't naive, shallow, or utopian. It may have narrowed his public, but not himself; he continued to attend art galleries and read art criticism and theory. He benefitted, too, from association with craft institutions that did not equate scale or weight with importance.

Those of us who are proud of the crafts and its traditions are honored by the presence of McQueen. He represents the skill, sensitivity to the past, attention to the tactile, love of materials, and absorption in the creative process that drew us to this field. But he also stretches our categories and is a constant reminder that skill is subservient to meaning in works of art that nourish the heart and mind.

As for semantics, the art critic and historian Lucy Lippard, writing about McQueen in *The Eloquent Object* (1987), said, "Containers or not, I would call them sculptures. . .if there were any reason not to call them what they are—baskets."

VICKI HALPER

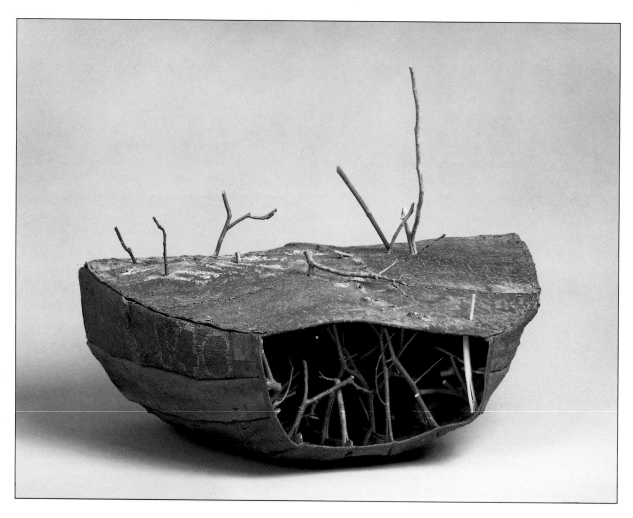

Here is a metamorphic slice of earth. Fragile, linear twigs,
denuded remnants, poke through the ground plane. Beneath is a mass
of roots, a glimpse into the hidden subsurface.

UNTITLED #140, 1986; white pine bark and mixed wood sticks; 21 × 27 × 16 in.

CONTAINING AND BEING CONTAINED

Ed Rossbach

"I am a basketmaker but before baskets I made sculpture. The transition came during a time I was working with sod (lawn grass). I worked this living material into works of art by planting it in cages of metal and forcing it to grow down toward a grow light instead of up toward the sun. From these pieces I moved to ideas surrounding the way man uses trees as metaphors for himself in nature."[1]

In John McQueen's baskets, as in his sculpture, sensitivity to nature is always part of an interaction with his natural inclination toward structural invention. McQueen, whose approach is unusual among contemporary basketmakers, selects, gathers, and prepares his own vegetation. The materials that he uses are of necessity native to his area. His baskets, while expressions of his response to all nature, speak eloquently of the area where he lives.

In embracing basketry, McQueen found that conventional basketmaking was too restrictive for him. Instead of conforming to the convention, he changed it. In compliance with his views, he has produced a body of work—a world of ideas, really, with one idea growing out of another in a wonderful procession of baskets, all recognizable as McQueen's. He speaks of "the basket re-defined." He insists with assurance that his works are baskets and that he is a basketmaker. Through such assertions and through the persuasive force of his work, he has become an acknowledged leader in the contemporary basket movement.

In 1988 when McQueen gave a lecture in Oakland, California, he began by speaking about his rural experiences—chopping firewood, working his garden, waiting for water to boil on a wood stove, living without electricity. He said that just before leaving for California he had been sawing blocks of ice from his pond for the ice house that would keep his food cool all summer.

I asked him later whether he always begins his lectures by describing his lifestyle. He said that he does. He wants his lectures to show the connection that exists between his life and his art. His way of life provides an easy means to make that direct connection. He said, "Art cannot come from art. Art must come from life."[2]

The relationship of his baskets to his land became so pronounced for me that, when I set out to write this essay, I felt obliged to speak first of his acreage. I wanted to see it for myself, but the difficulties for me of getting from the airport to his place near Alfred in western New York State persuaded me that what was important, after all, was McQueen's perception of the land and how this perception influenced his work. I looked at slides that he sent me, listened to what he said, and pondered how a particular place can evoke an aesthetic response—how a sense of place can be expressed in some other visual art than landscape painting.

Only a barn, which McQueen now uses to store basketry materials, stood on his property initially.

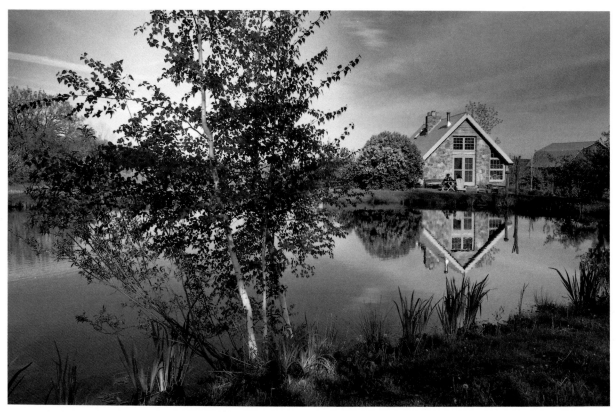

John McQueen's home, Alfred Station, New York, 1991.

The first thing that McQueen and his wife Jessie She-frin did was put in a pond, something that the county encouraged landowners to do. They then built their house in relation to the barn and the pond, using stones that farmers throw aside when plowing their fields. The familiar, easily recognized materials of the house recall the tree barks and other vegetation McQueen uses in such a straightforward manner in constructing his baskets. The house, like the baskets, speaks of nature and McQueen's respect for the natural landscape. It has an intimacy and charm, even a kind of delicacy, rather like a cottage from England's Lake District. A sense of splendid solitude pervades the setting. The house, the barn, and the pond, ar-ranged together, somehow seem to support each other, alone against the vast panorama of nature. The surrounding, containing, rolling hills seem to extend endlessly.

Hearing him talk, and looking at his baskets, I fan-cied that McQueen had made a pact with his land: It would provide physical materials and mental and emotional stimulus, while he would furnish personal responses and formal structures. In a symbiosis be-tween nature and art, the land would become the bas-kets and the baskets would become the land. Through his baskets he would simultaneously express his love of the land and a great deal about himself.

McQueen seemed to have stretched a string—the way kids in summer camp will mark out a patch of nature and observe everything that happens in that space—outlining his eight acres. What would happen in his baskets would happen in relation to that space. His works seem constructed wholly of materials that he gathered on his land in the course of a year—elm bark, white pine, cherry bark, grape vine, burrs, etc. Everything is familiar to him. He feels a deep involve-

ment with his materials. All can be put to use, understood, and transformed, with a sensitivity and respect that, along with great structural ingenuity and skill, are the hallmarks of his work. (Mainly I think of his baskets as *ideas* expressed in constructions of amazing imagination and beauty.) Each material finds a use that determines the basket's form. His baskets seem akin to the living trees that he has pruned and manipulated on his property—trees that he has bent and tied into living configurations unknown in nature, yet, at the same time, part of nature.

I asked him whether he feels a bond with the trees when he makes a basket. "Yes, I think I do," he said:

I think about what a tree is, the nature of a tree, how it is organized, what it stands for. I think a basket is about organization. Our minds are always organizing things. That's one part. The other part is the mythology of trees.

I do think that my pieces, as time goes along, are more and more about trees. When I started making baskets in New Mexico and Philadelphia they weren't about trees but about the idea of containment.

Now that I am growing trees, doing espalier and grafting, my life is more about trees. Therefore I think about trees. Therefore my work is more about trees.

To him the features of trees—the roots, knots, forks, bark—carry meaning. Similarly, baskets embodying these features carry meaning. He believes that trees speak of our longing for organization, order, and completeness—the very qualities that so remarkably characterize his baskets.

The meaning in his baskets may not be the same for everyone. McQueen recognizes and accepts this fact. Indeed, he welcomes a variety of responses to his work. He wants the viewer to find his or her own meaning.

Before he became interested in making baskets, and before he moved to the country, McQueen was using living materials in his sculpture. He liked that he had

to water his art. From these living pieces he moved to ideas about trees as metaphors. He once wrote, "If we drive a nail into a tree, it is as though the nail is being driven into our own body. It is as though the tree knows human pain." To McQueen,

trees represent the accumulation of our concept of nature stored in our unconscious. Trees are an image of our determination to rule the world. But at the same time they are an image of our fear of nature; a fairy tale fear of the "deep, dark woods" where man is lost and out of his element.

He has also said:

I think we see trees as a symbol of nature, both good and bad. We feel we have to control them,

Manipulated trees on John McQueen's property, 1991.

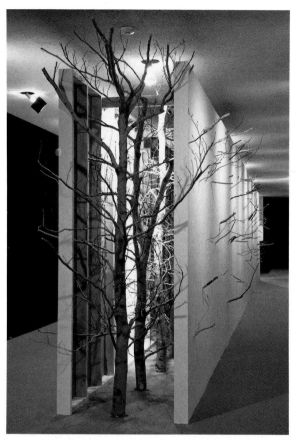

Tunnel Vision/Frontal Vision. A collaborative installation by John McQueen and Jessie Shefrin at the John Michael Kohler Art Center, Sheboygan, Wisconsin, 1986. Materials are wood, drywall, paint, tree limbs, and colored lights. Total size: 8'11" × 53'3" × 6'10".

prune them and thin them out. I'm sure they'd be perfectly happy without that. It's our way of being in charge of the world, and I think a tree stands for that, whereas a blade of grass doesn't.

In 1986, when John and Jessie had an opportunity to work together on a collaborative project at the John Michael Kohler Arts Center in Sheboygan, Wisconsin, they chose to do an installation of a long row of trees sandwiched between two confining walls. The branches seem to be pushing violently, penetrating the walls. Trees and man seem to be in confrontation, with the trees prevailing. The parallel walls create a narrow tunnel that the trees choke with their

branches and shadows of branches. It is an emotionally disturbing piece, just as are many of John's tunnel baskets. At the same time, the installation was able to refer to Monet's pleasant rows of poplars, regularly spaced, sandwiched in idyllic glowing space.

John McQueen was born in 1943 in Oakland, Illinois, a town with a population of one thousand. He has childhood memories of Midwest cornfields and open plains. His father was in the airplane business as a licensed mechanic. The airplane business didn't exactly thrive in the middle of a small farming community, so the family moved to Fort Lauderdale, Florida, when John was about ten. Back then, Florida still had something wild and uncivilized about it: "One could see alligators walking across the back lawn, and hear them at night," McQueen recalls.

Although not deeply involved in nature as a boy, McQueen knew that Florida resembled a big botanical garden. The abundant vegetation, however, served as background to a life more centered on mechanical objects. His father had all the tools and his three brothers were all mechanically inclined, so his interest in mechanics "was in the atmosphere."

McQueen believes that the way he makes baskets is connected to this childhood interest in mechanics: "I more or less build baskets. I always connect that with my father's building planes, fitting parts together. It is a type of construction or building I got through osmosis."

McQueen's mother introduced him to art: "She was always drawing or painting, and always encouraged me." He remembers his intense desire for a boat when he was about fourteen. Since his family could not afford one, his mother suggested that he simply design one and build a model. McQueen envisioned what the boat would be and made paintings of it on the walls of his bedroom. It became real to him.

This way of working is related to a 1973 project McQueen undertook while living in Albuquerque after completing college. He worked as an auto mechanic and would go to a nearby park on his lunch hour. The park had a locomotive on exhibit that in-

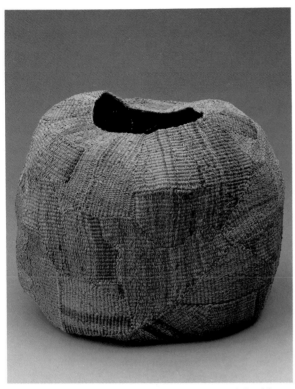

UNTITLED #11, 1976; morning glory vines and day lily leaves; 11 × 13 × 14 in.

Flat woven patches of leaves and vine are joined to make a basket that looks like an archaeological reconstruction. The inspiration was a smashed bottle that McQueen found and reassembled in 1975.

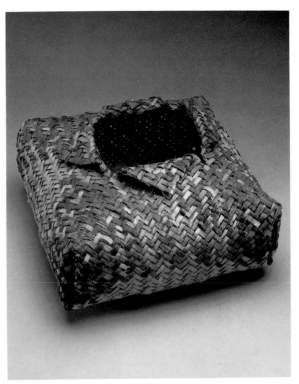

UNTITLED #13, 1976; basswood bark; 7 × 12 × 12 in.

McQueen often starts his workshops by asking students to transform two-dimensional surfaces into three by folding paper. This basket started as a flat, woven mat that was ingeniously folded into a fortune-cookie-shaped container.

trigued him. He proceeded to sketch the mechanism in a remarkable way: he mentally divided the steam engine into a number of squares, like the squares of a grid. Each day he would concentrate on one square section, memorizing all the structural details while he ate his lunch. He preserved this image in his head until returning home after work when he would transcribe the mental image onto paper. John could simply have taken a sketchbook to the locomotive or he could have taken a photograph. But what he did became a different experience—an investigation of time and memory contrasted with the intricacies of mechanical detail.

McQueen became aware of and interested in making baskets during this time in New Mexico. The ma-

terial of baskets, along with their intimate size (especially as compared with the large sculptural forms of adobe that he was then involved in), greatly appealed to him. Although he acknowledges his debt to aboriginal basketry, he didn't learn to make baskets from Indians. McQueen learned the art on his own: "I looked at a basket and figured out how it was made, and I made one. Of course, the first one was not very well constructed." With courses in weaving the only entrée into the study of basketmaking, McQueen decided to enter the textile program at Tyler School of Art in 1975. In the first year of graduate work, he concentrated on learning to weave; the second year he focused on baskets.

McQueen did not follow a prescribed course in weaving, but acquired technical information only

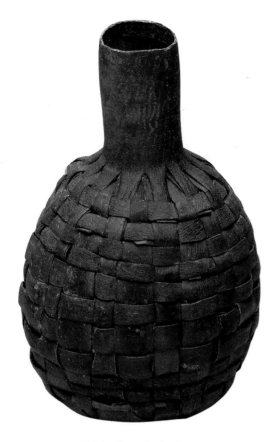

UNTITLED #16, 1976; white pine bark; 17 × 10 × 10 in.

McQueen pulled the core of a tree limb out from under its bark in the spring, when sap rises and the interior and exterior of a tree cleave less tightly. The neck of this vessel is the skin unsplit; the inflated body is the skin sliced and interwoven with more bark.

when he needed it for his ideas. He wove what he described as "three-dimensional structural things." He speaks of weavings in which separate layers open up like pages of a book. They show no lettering, only gray stripes that suggest a printed message that doesn't say anything:

> I had no background [in weaving], so I wasn't intimidated by it. I just said, "How do you do this?" and somebody showed me how and I figured it out. I was in a group situation with a lot of weavers. I just said, "This is what I'm making. How do I go about it?"

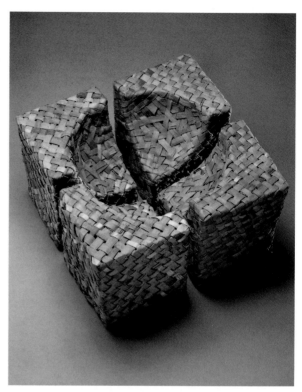

UNTITLED #33, 1977; basswood bark; 10 × 16 × 16 in.

A four-part "basket-by-association" ceases to be a container as soon as it is lifted or a piece is moved. The careful geometry is a circle within a square sectioned by a cross. Strict plaiting checkerboards the exterior. But the interior is a jumble of random weave, mocking the symmetry and external order.

He tried to weave in different directions at the same time, and he did a lot of off-loom manipulation. He covered surfaces with burdock and stacked them up like a sandwich. Later on he combined cotton yarn with morning glory vines in a woven panel. Weaving and basketry techniques became intermixed in baskets that are technically ingenious.

Early in his basketmaking, McQueen started working with forms or molds that he constructed from paper, cardboard, and masking tape. Molds have been used traditionally for controlling precise forms. The emphasis was on shape, volume, and geometrical precision. He would apply surfaces over the molds, then remove the paper molds when the baskets were com-

pleted, leaving a construction of bark or whatever material had been applied (*Untitled #7, #19*).

Working over a form gives a pre-planned look—a kind of precision and regularity that is impossible to achieve without a form. In devising a form, the artist can use a ruler and compass, can measure intervals, etc. Such precision, in keeping with McQueen's very refined sense of craftsmanship, gives a look that characterizes his work.

The material that McQueen stretches over forms is most often plaited or patched together by sewing. The plaiting method is especially delightful because the skin becomes a sort of seamless whole with no indication of how the mold was removed (*Untitled #33*). The plaiting tends to modify and thicken the form because the plaiting technique doubles the thickness of the skin layer. The sewing method divides the surface into many irregular shapes that are outlined with raised ridges and sewing (*Untitled #189*). Forms become bold and vigorous; the seams moving in all directions become a dominant feature, active and gestural. The thickness of the skin is revealed in the raised edges. The stitching necessarily has a heaviness that is most appealing.

McQueen began using segments of trees as his molds. When splitting firewood he began to keep logs that looked interesting to him. He used these branches and logs as they occur in nature, without modification of their chance growing patterns. The natural irregularities are preserved in the sewn or plaited bark that he applies. In this way he avoids the controlled geometric perfection of his earlier work

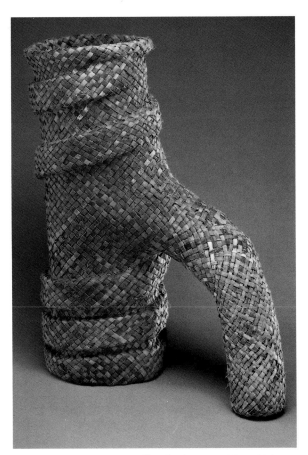

UNTITLED #202, 1989; willow bark; 26 × 20 × 10 in.

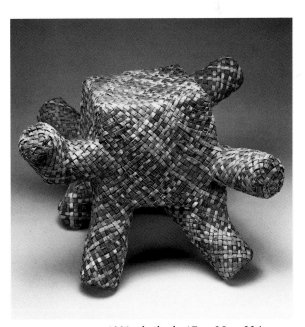

UNTITLED #215, 1990; elm bark; 17 × 25 × 23 in.

This gawky basket, all arms and legs, is like a cube granted sudden locomotion or an infant learning to walk. McQueen has said, "If it could walk, it would limp."

Untitled #202: **The uniform checkerboard texture of the plaiting unites the disparate parts of this basket. The spiral widens to accommodate the flying buttress of a limb that braces the woven column.**

and achieves what he describes as a more organic look (*Tree in Its Skin, #112; Untitled #163, 189, 121*).

Using a branch or log as a mold encourages less precision not only in the overall configuration of the basket, but also in the construction of the skin. McQueen took pieces of bark and fit them together with rough vigor and spontaneity: as a result, the baskets evoke trees and nature in a wonderful way. Sometimes the results appear relatively loose and casual, improvised, and free of intellectual restraint. By using forms from nature, McQueen achieves shapes that otherwise might never have occurred to him. The applied surfaces seem to become more animated in response to the liveliness of the natural forms. In discussing one of these recent baskets, he commented, "I couldn't make this up. This is a piece of a tree, and I don't know that I would have made it that awkward if I had decided abstractly to do it. I really like it. There's no designing, just selection. It's nature. The

One of John McQueen's basket molds, ca. 1988.

tree has really made the piece." His technique is to select a part of the tree "to do what I call my work."

Generally, McQueen selects pieces that have jutting limbs (*Untitled #163*). He feels that the energy of the tree is concentrated at the juncture of trunk and limb. Commenting on one of his pieces he said, "I didn't decide on specific angles. I simply cut off the tree trunk and turned it upside down, covered it with bark and let it dry." He retains in his baskets a sense of the forks, knots, etc., just as they occur in nature—these are the kinds of features that McQueen responds to.

McQueen's uses of materials and techniques are difficult to explain—perhaps they must be intuited. His art encompasses not only traditional ideas of baskets, but the effect of the environment and the sensations of a particular place as well. From all this he creates something new, a synthesis of ancient respected traditions with idiosyncratic innovations—all assembled with personal forcefulness and remarkable independence and confidence.

In the first exhibition of baskets by McQueen that I ever saw—this was in 1980—he seemed to be preoccupied with entrances to an interior maze of great complexity. As I remember the works, there were no exits, only entrances. (I don't know how I distinguished entrances from exits.) The viewer was allowed inside via passages that were as much implied as actual. Sometimes the baskets seemed to be traps set for the viewer. Like his later baskets with lettered messages that cannot easily be read, these early baskets appeared secret and ingeniously enclosed. I had the distinct impression that McQueen's works were not as direct and straightforward as they appeared with their exposed constructions. At the time that I saw these baskets I wrote in my notebook, "I suppose that all baskets are enclosures, with ways in and out. The emphasis is different in each case. McQueen's baskets appear preoccupied with the way in."

A word that appears in much of what McQueen says is *control*—by which he suggests a concern with man's will to control nature and his own will to con-

trol nature (i.e., trees) in his baskets. The varieties of control that he exerts in his works are not limited to one material or one technique, but are evident in the great variety of his works. It is as though he has an unlimited storehouse of skills and abilities (and comprehensions) to call upon. Paradoxically, the control that McQueen demonstrates seems to be accompanied by a desire for greater freedom—a desire to surrender some authority, some of the mental control he exerts: "Maybe that is why I use logs as forms. They release me from that control."

McQueen learned to make splints—a very physical process—in 1975. It's hard work, yet he loves the magical way the splints peel off, like sunburn. He said that although he has to pound on the log for a long time, the nonthinking labor is a satisfying outdoors activity in the summer.

He keeps a large supply of materials on hand: "I collect enough in the summer to last through the winter. Some material, like bark, will not come off the trees in winter. But mainly I want to be outside in the summertime and collecting materials gives me a reason." Since he can't be sure what he'll want to use, McQueen has to have as much raw material as he can find.

He uses certain materials more than others. The small elm trees where he lives provide the strongest material he has yet discovered; he uses the smooth cambium layer, not the big rough outer bark, which is too stiff.

The burrs that stick on his socks and pants inspired a new method of nonwoven, nonpatched construction (*Untitled #192*). The burrs are gathered in the fall and cannot be stored. McQueen works with them on-site, constructing his baskets beside the burdock plants:

> I have a small tractor with a trailer on it and I pull up next to the plant and build the pieces right there by taking the burrs one at a time from the plant to the piece. It is nice in the fall out there with the leaves turning and winter coming on. Among other

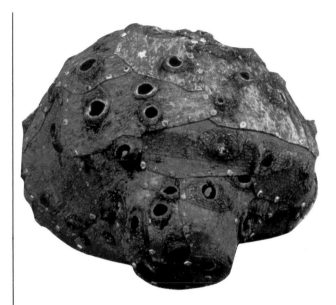

KNOT HOLE SPRUCE SKIN (#220), 1990; spruce bark, orange peel, and plastic rivets; 15 × 22 × 18 in.

Instead of discarding those pieces of bark that are marred by knotholes, as he usually does, McQueen used them exclusively in this warty, punctured work. The basket rests like a piece of rotting fruit or a skull.

things, these burr pieces are about trying to make this outdoor activity physically exist in the object.

The gathering of basket materials at the appropriate time during the year establishes certain rhythms in his life and art. Activities change in relation to the seasons. To an extent he is controlled by the seasons, just as farmers are by planting and harvesting. His life patterns are in a clear relationship to nature. Nowadays, when many artists feel (or want to feel) unfettered by the past, it is surprising to hear McQueen speak of traditions in baskets in relation to what he is doing. He describes baskets as objects from our dim archaeological past, predating the cave paintings. For him, baskets cannot be said to have ever had a beginning—they are our first achievements, as old as human existence.

McQueen feels emphatically linked to the basket tradition. When people ask whether he considers his baskets to be sculpture, he says they are *not* sculp-

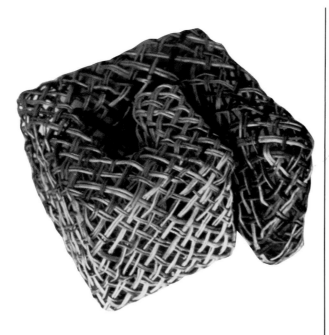

UNTITLED #89, 1979; spruce roots; 8½ × 13 × 13½ in.

McQueen created his first spiral basket after contemplating a roll of fencing in a hardware store. A basket that moves through space, its webbed walls circle around themselves to create a container as maze.
McQueen considers this linear and directional form to be masculine. In contrast, a classical basket would be feminine, with emphasis on its interior rather than its profile.

ture. To him, sculpture—compared with basketry—is a late development: "Baskets have enormous variety, history, and distance. To me, my work is in the basket tradition, no matter how far I push to the edge of its traditional definition."

McQueen feels that calling his work baskets rather than sculpture gives him a real advantage: "There's no limitation. I think sculpture, because of its place in the hierarchy of the fine arts, has more rules, requirements, and preconceptions. The advantage of having baskets ignored by modern western cultures is that baskets are allowed to be whatever I want—the rules haven't been determined." He adds, "Baskets connect with the definition of a container—a very broad concept. This room is a container. I am a container. The earth is being contained by its atmo-

sphere. This is so open, I don't need to worry about reaching the end of it."

McQueen never signs and rarely titles his baskets, affectations that he feels are not part of the basket tradition. Since the pieces are numbered consecutively, this system has an advantage: a viewer can roughly place a basket in its time sequence—basket *#1* is McQueen's first; *#200* is recent. Looking at a large group of baskets, or slides of baskets, arranged according to number, a viewer can get a feeling for the way McQueen works—how a sequence of baskets concerned with reconstructing bark surfaces may be interrupted by a sequence of works concerned with entries and exits, or one of clumsy burr baskets, or of delicate structures with interiors and exteriors simultaneously visible.

McQueen is known for his incorporation of words into the basket's structure and decoration: "I think I first put words on baskets because I became interested in the basket surface," he has said. "I didn't want to use ancient symbols such as lightning bolts or crosses, but imagery from my own culture. The written word seemed to fit perfectly. However, I immediately realized the written language has two aspects—the meaning of what's written and the physicalness of the letters. Letters take up space on the page. They have at least two of the three dimensions. I tried to find ways to make the written language more and more physical." His lettering has the substantialness of basketry, of natural vegetation.

The words function in a variety of ways. Sometimes the individual letters actually hold the basket together (*Untitled #106*). Sometimes they have a relationship to the shape of the basket. Words can enter openings and exit from other openings. They can be transformed from one letter to another in the process of moving through (*Untitled #197*). A basket that says *OUT* is made up of letters that are tunnels that pass through the basket from one side to the other. The word appears on the outside of the basket but also runs through the basket from the exterior through the interior then out again (*Untitled #203*).

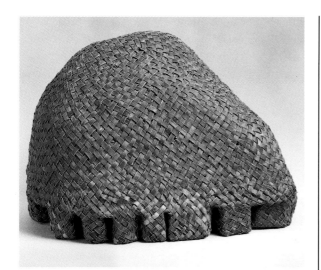

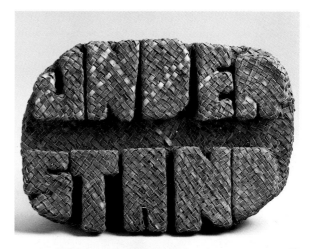

UNTITLED #182, 1988; elm bark; 16 × 22 × 16 in.

The artist created a cardboard form around which to mold this basket copied from a small rock in his collection. The soft, quilted surface gives the shape a lumbering, slothlike body supported by stubby legs. When the basket is upended, these legs are revealed to be the ends of chunky letters that wryly spell "UNDERSTAND." In the basket's usual position, the blocky letters are viewed from an angle that renders the text incoherent.

The individual words that McQueen weaves into his baskets usually form sequences poetic in appearance as well as in meaning. The words seem concerned both with sound and visual repetitions. There is an almost palindromic continuity from the endings to the beginnings of phrases. The reader can break into a message at any point in a word or sequence of words, and go on from there:

> *It seems*
> *To be seen*
> *Is too seen*
> *To be said.*
>
> *Always is always a ways away*
>
> *Even trees are uneven*

The longer messages are poems. When such poems appear on a basket, the visual impression is altogether different from what it is on a printed page. Visual relationships of words and lines are radically altered. Being able to identify only one word or letter at a time, the viewer changes the rhythm of sounds to something halting. The message is transformed.

Knowing that the words are intended to be read, the viewer handles the basket or moves around it (*Untitled #107, #165*). Usually only a word or fragment is visible at one time. These fragments are like graffiti flung in the face of the beholder, who may understand nothing of the total message. There is a

powerful impact, even though it may not be the impact that the artist intended. McQueen is willing to have his works interpreted in various ways, although his words are always carefully chosen.

McQueen is interested in observing people as they look at his baskets with words. He feels that he can see their faces change when they observe that the visual patterns are words: "Suddenly their expressions change. Sometimes I can see it physically happen—the left and right sides of the brain make contact."

Words carefully constructed on a basket that seems to be a section of a log suggest words carved on a tree trunk or cut into a school desk with a pocket knife. Such words and initials have a special impact—they are so isolated, suggestive, without knowable references. Likewise with these baskets—there is an anonymity that seems to extend even to these objects created by a named artist. There is meaning that cannot be divined. The viewer feels frustrated trying

to intuit an intention, for the words plaited into bark strips, or hung miraculously in space, suggest a commitment on the part of the artist to communicate meaning beyond the physicalness of the letters (*Untitled #150*).

The words on McQueen's baskets are often difficult, or virtually impossible, to read. Yet illegibility is not part of his intention. He wants the words to be read, even if that is sometimes difficult. He doesn't want to create a puzzle that can't be solved. He believes that reading the words is important to appreciating the baskets—as important as looking at the baskets.

Almost all the words that appear on his baskets are messages that he made up. He keeps a journal, a sketchbook, that consists more of words than of pictures. In it, he works out the text that will go on his baskets. Recently he has tended to use only one or two words—something short, to the point.

When he was asked for a statement to accompany his basket in the Erie Museum exhibition of new basket forms, he decided that he made written statements over and over on his baskets, any one of which could be used. He sent the museum a listing. "I liked the way it turned out," he reports. "They used the whole list."

Lettering allows for humor, which is not too common in basketry. The artist seems to be playing with the words, for his amusement as well as his delight at constructural ingenuity. McQueen's work plays with the physicality of words—his baskets often have a humorous quality that derives not only from the words but also from absurd, unexpected shapes (*Untitled #182*).

Some of the messages seem like incantations. Others seem obscure and enigmatic, relating the words to those used by the early surrealists, who achieved shock and surprise and sometimes established unexpected relationships in their work. Sometimes the words seem like a technical tour de force, an exhibition of skill, which has for a long time been one of the delights of basketry.

The lettered baskets (which greatly appeal to me) recall the Near Eastern clay documents inscribed in the ancient cuneiform script, which a museum once labeled, "The contents are yet unread." The presence of the lettering enhances these documents as works of art. They inspire emotions, speculations, imaginings. In the McQueen lecture that I heard, he showed slides of a basket with a rather long message that he read to the audience and then read again at the audience's request—to their great delight. The message was obscure to me in both readings. Yet I felt pleased that the lettering was there, that an artist had painstakingly constructed these words that seemed hermetic. They had the power to delight an entire audience as well as the artist himself.

As the inscriptions on McQueen's baskets have become shorter and more easily deciphered, their significance seems to have changed. They are more obvious, there is less mystery, more of a kind of meaningful meaninglessness. I think of his early weavings that were pages forming books that carried no messages, only gray lines that implied but said nothing, although perhaps saying a great deal.

Words have such fascination—such potency—when they appear unexpectedly, seemingly out of any context. The town next to Alfred—Canisteo—has a living sign of trees, each ten or twelve feet tall, like a hedge, spelling out the town's name. McQueen says, "I love it."

1 John McQueen, unpublished statement on his work, n.d.
2 Unless otherwise noted, all quotations from John McQueen are from conversations with the author on 29–30 March 1990 at the Renwick Gallery of the National Museum of American Art, Washington, D.C. Supplemental information was obtained through telephone conversations.
3 McQueen, unpublished statement.

Untitled # 19: **Like Untitled #11, this basket is assembled from patches. Each black pine bark segment has notched edges in which the cambium layer of the wood has been exposed. The notches interweave, leaving their light tracery as the record of the gathering of broken parts into an enclosure.**

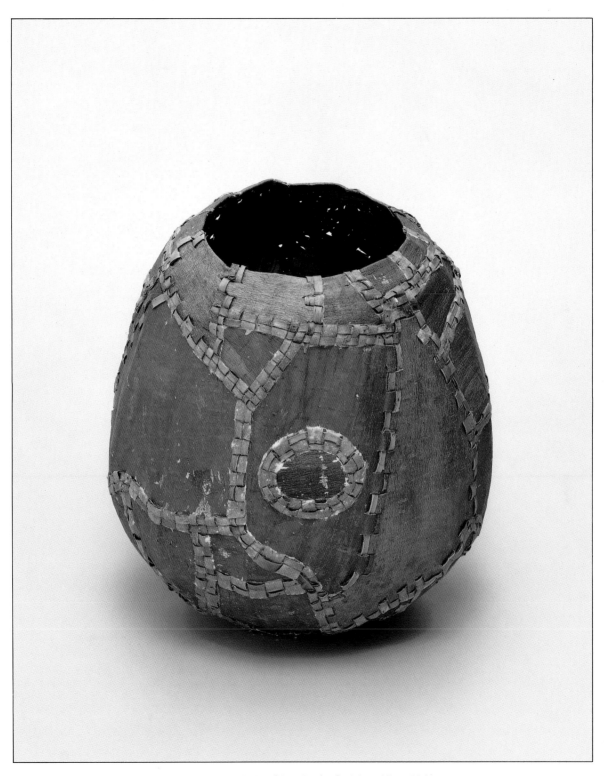

Untitled #19, 1977; white pine bark; 24 × 15 × 15 in.

Untitled #25: A series of nesting shapes, each lined with moss, forms the soft layered walls of this gossamer-light basket. The boldly patterned malaluka bark is controlled both structurally and visually by ordered stitching.

Untitled #80: Before 1979, the surface designs on McQueen's baskets consisted of the textures and colors inherent in his materials and the patterns of his weaving and assembling. The intricate surface of this basket is the result of notations left from construction—the numbering on each segment—as well as decorative stitching and piercing.

The hieroglyphiclike marks are the precursor to McQueen's word baskets, the artist's eventual solution to his search for surface decoration devoid of archaeological referents—a surface both modern and meaningful.

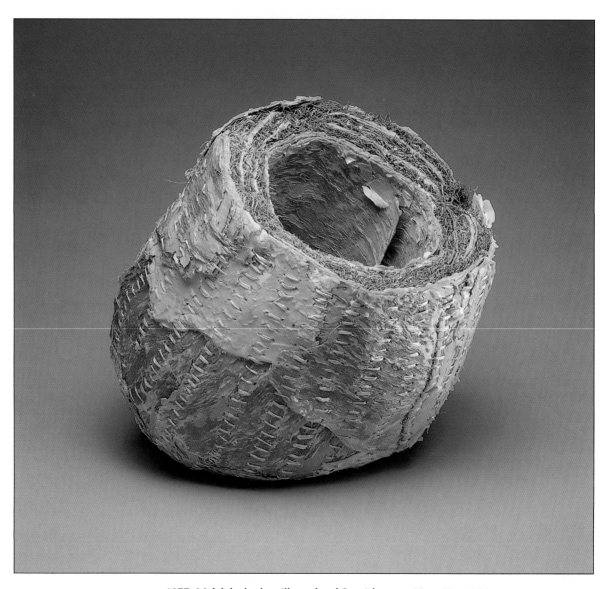

Untitled #25, 1977; Malaluka bark, milkweed and Spanish moss; 15 × 10 × 10 in.

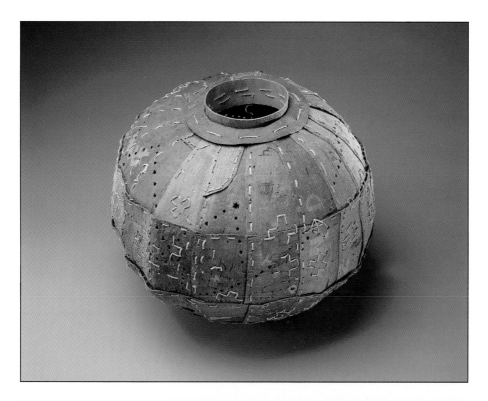

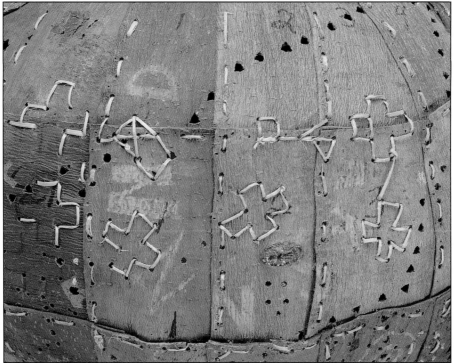

Untitled #80, 1979; white pine bark, tulip poplar bark, ash bark, and ink 12 × 16 × 16 in.

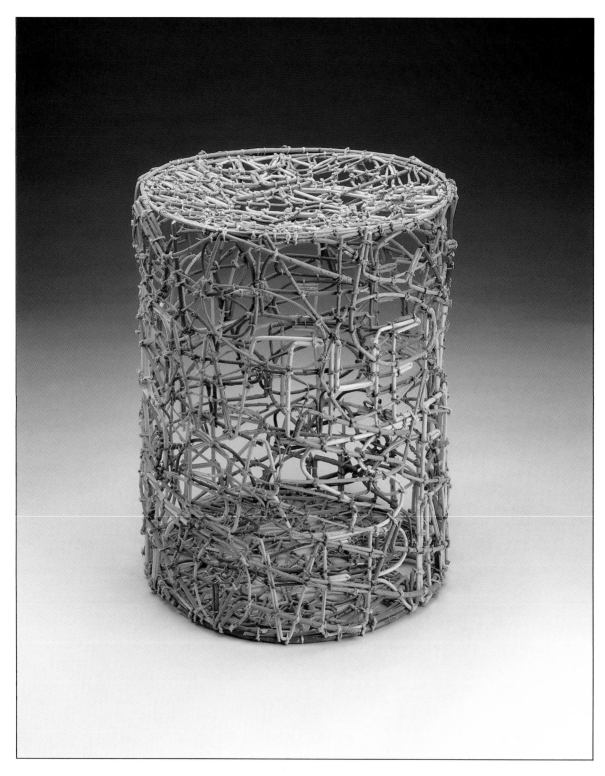

Untitled #106, 1982; red osier, willow, and elm bark; 16 × 12 × 12 in.

Untitled #106: Words structure this basket. Its webbed walls are formed by three layers of language, written in three colors of twigs, running in three directions—like a mind swirling with thoughts. The sentences parallel to the base circle endlessly as the last word meets the first and the cycle repeats. This word play is possible when letters are seen as dimensional objects rather than simply symbols on a printed page.

Many of McQueen's concerns are present in these words—the ambivalence of enclosure, which both traps and provides safety ("Trapped is a safe feeling"); the absolute separateness of individuals ("And each one crowding around is alone"); and the elusiveness of the present ("Covering the past with covering the past with . . .").

Top:
1. *Trapped is a safe feeling*
2. *What comes out lies in wait*
3. *Away from what I cannot say*

Bottom:
1. *At last I am what I am all at once*
2. *And each one crowding around is alone*
3. *We are sometimes all of us always*

Side:
1. (diagonal) *Around and around and around*
2. (horizontal)
 a. *The end is next to (the end . . .)*
 b. *Now then spreads (now . . .)*
 c. *Striped bass eat (striped bass . . .)*
 d. *Covering the past with (covering . . .)*
3. (vertical) *Later it comes back and so I think of it, I talk to myself about it*

Untitled #107: Text becomes structure in this basket, in which ash splints are stitched together with words. The sentences are legible only from the inside of the cylinder, which, to permit reading, is bottomless. The exterior has an evocative patterning, like the backside of a label—the evidence of hidden meaning.

> *You know the way a number of ways are always waiting and the way we use the numbers to hide the meaning of our being. And what seems to be stable changes from one to another is really our way of interrupting understanding; and in so doing we keep going without knowing if we are turning or returning.*

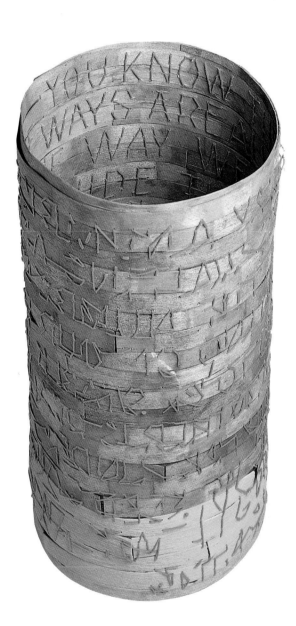

Untitled #107, 1983; ash and string; 18 × 9 × 9 in.

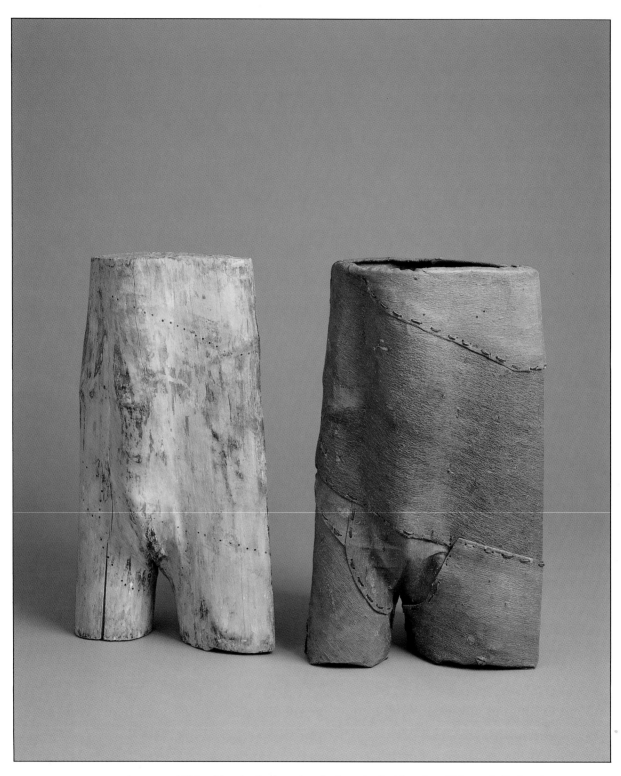

Tree and Its Skin (#112), 1984; white pine bark, walnut bark, and ash; 18 × 9 × 10 in. each (2 pieces)

Tree and Its Skin (#112): In *Tree and Its Skin,* McQueen reveals a new way of conceiving baskets that will influence much of his later work. A log, picked for its anthropomorphic qualities, becomes the template for a stitched bark basket. The solid, heavy mold is displayed beside the weightless shell.

McQueen has limited his creative role to choosing the proper template. Paradoxically, this restriction grants him freedom—from symmetry, geometry, and engineering—and allows him to concentrate on evocative images from nature.

These baskets, hinting at bodily fragments, were molded from a pile of logs. They are placed in a tight ceremonial circle, echoing ancient sacred monuments and rites.

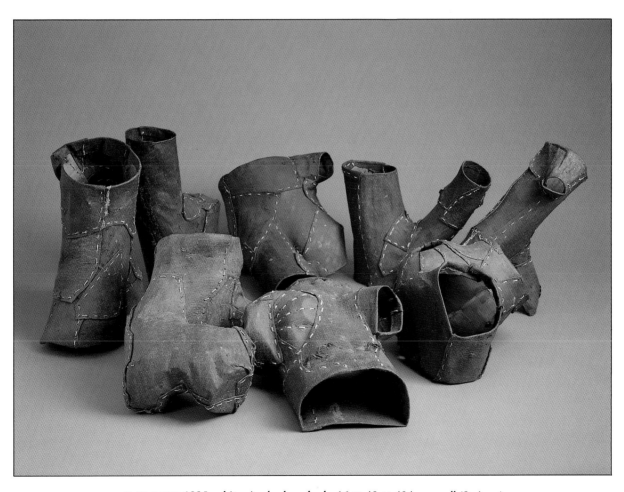

Untitled #121, 1985; white pine bark and ash; 16 × 40 × 40 in. overall (8 pieces)

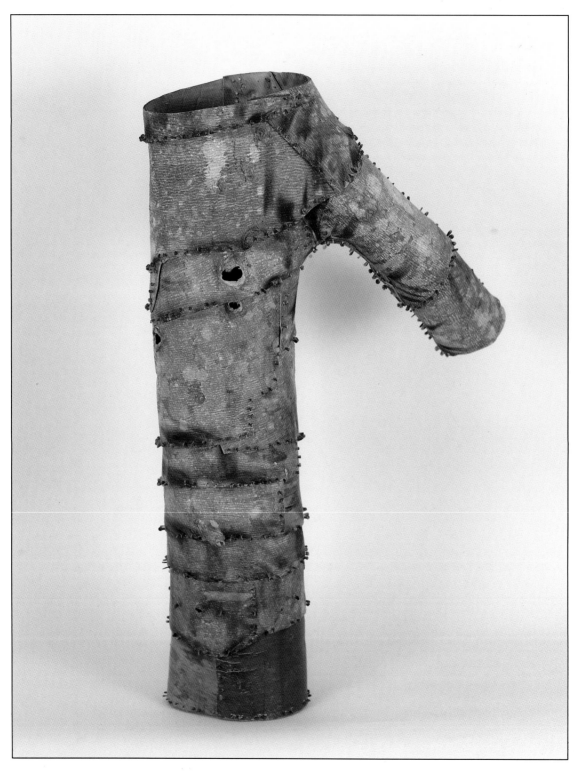

Untitled #163, 1988; tulip poplar bark and plastic rivets; 29 × 17 × 12 in.

Untitled #163: The joint where branch meets limb is full of
energy. McQueen has said, "If it could move, it would dance."

Spiral and nest combine to create a twisting basket with a
porcupinelike surface. The pick-up-sticks structure is achieved
without plaiting, stitching, or tying. It is the artist's first large-
scale work.

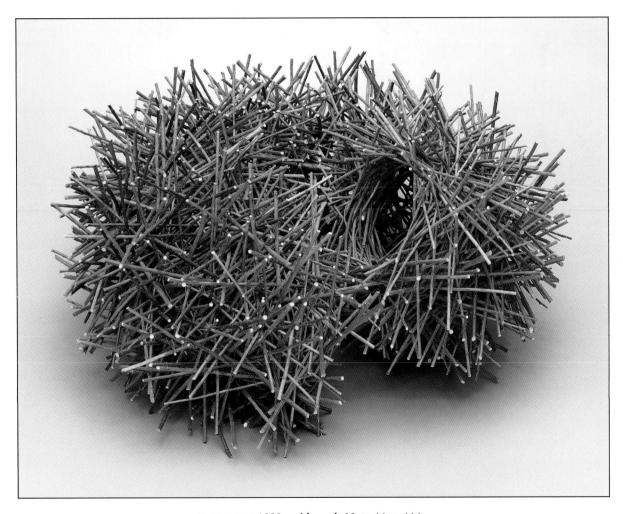

Untitled #183, 1988; goldenrod; 22 × 44 × 44 in.

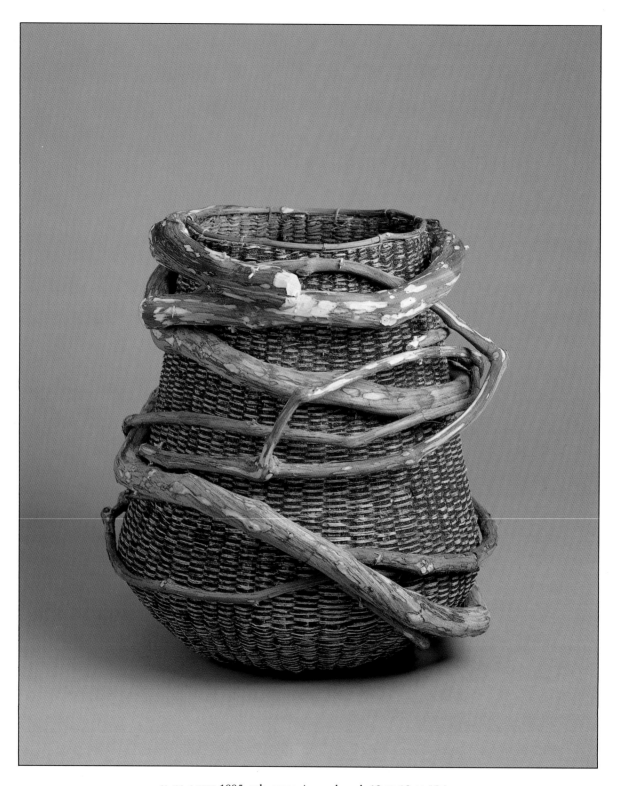

Untitled #125, 1985; ash, grapevine and mud; 18 × 18 × 18 in.

Untitled #125: When does an embrace become a stranglehold? Will nature's irregularity overwhelm humanity's will to a measured order?

In baskets *#94* and *#125,* spiraling twigs grasp vessels. In *#89* and *#176,* the spirals become twisting burrows leading to dead ends. Here the organic coil suggests a cobra, wound to strike. The sprouting ends of the basket are a reminder of the vegetal origin of the plaited ash.

 The piece is a technical tour de force, possibly the first time a hollow coil has been plaited. Splints are added to the expanding external side of the tube and removed from the contracting internal side to create the spiral form.

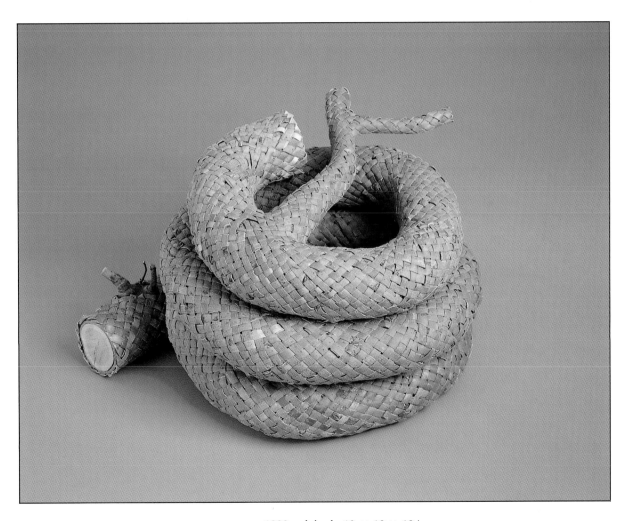

Untitled #176, 1988; ash bark; 12 × 19 × 19 in.

An awkward shape, snatched from a pile of firewood, was the mold for this plaited basket. The openings are placed where limbs once emerged from the main trunk. The shape is ungainly; the form somewhat forbidding. According to the artist, this basket "makes no concessions to beauty."

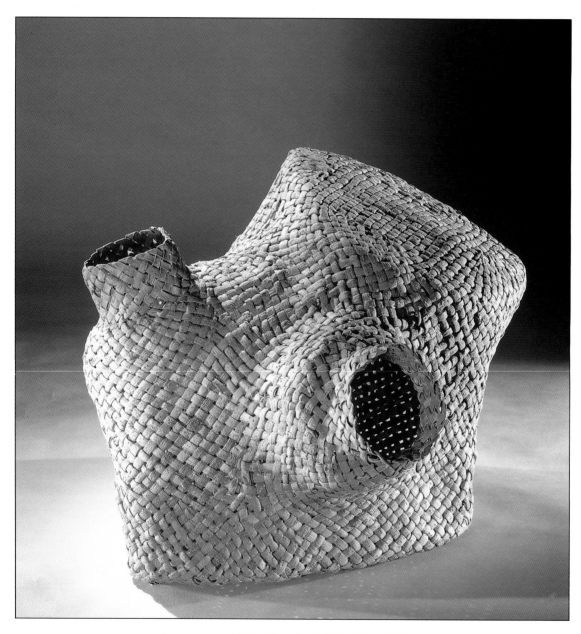

Untitled #187, 1989; willow bark; 16 × 22 × 18 in.

McQueen, a meticulous craftsman with an engineer's
sensibility, turned again to his woodpile to achieve
the lopsided, spontaneous vigor of this basket. Its exclam-
atory neck-tail-handle punctuates a blocky, armored body.

Untitled #189, 1989; spruce bark and plastic rivets; 15 × 32 × 13 in.

Untitled #192, 1989; burdock (burrs) and applewood; 23 × 19 × 20 in.

Untitled #192: This basket is formed with self-adhesive burrs. Like the bonsai McQueen admires and creates, the supporting form is analogous to the earth and the emerging twig to its venerated trees. One root disappears into the disquieting and mysterious interior of the vessel.

Untitled #203: Each letter penetrates the basket and emerges unchanged on the opposite side. The vessel is masculine—phallic and imperative. Rather than softly enclosing, the basket orders us "OUT."

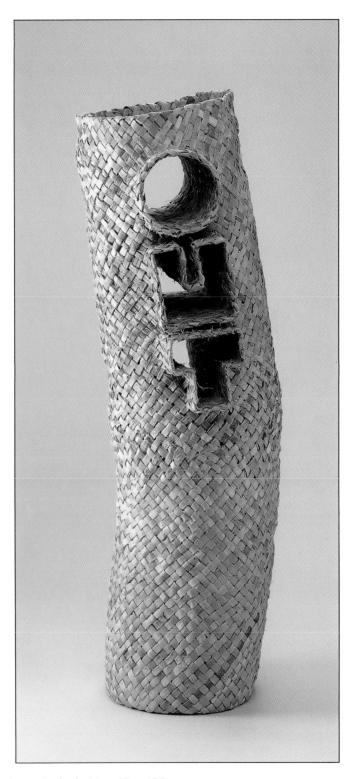

Untitled #203, 1989; tulip poplar bark; 31 × 12 × 12 in.

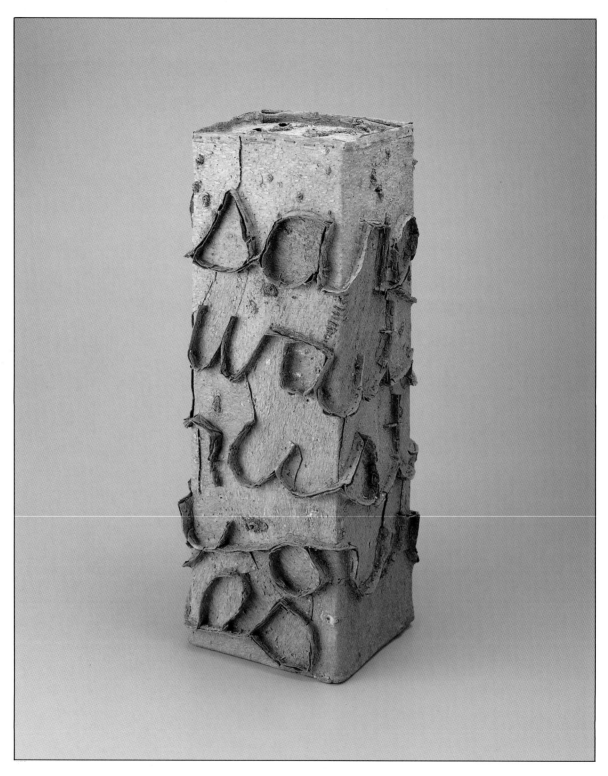

Silence (#228), 1990; spruce bark, string, and plastic rivets; 27 × 10 × 10 in.

THE LANGUAGE OF CONTAINMENT

Vicki Halper

Definitions

Writing in his journal in 1977, John McQueen outlined the essential characteristics of a basket. He described a singular, three-dimensional object, a container with a bottom and a hole at the top. Woven of long narrow strips, the basket should be no wider than an arm span and light enough to carry. No sooner had McQueen defined this ideal basket than he ran from its constraints. In the following years he would explore, change, enlarge, and contradict every one of these attributes.

Having called a basket a singular object, McQueen in 1977 created a four-part ensemble whose basket-like quality depended on the proximity of its parts (*Untitled #33*); its coherence dissolves when a segment is moved. In this basket, McQueen abandoned the self-containment of the solitary vessel and the portability associated with light, singular objects.

Bottoms and holes constantly migrate or disappear in McQueen's baskets. In the pipelike structure of *Untitled #30* (1977), the flat ends do not act as a stable bottom to the rolling form, and the interlocked

The words spiraling this basket are its seams. The writing suggests that humans are temporary, barely tolerated residents of the earth. Even the artist braves nature in creating his oases of order.

Trees are only waiting for us to bury ourselves.

ash and pine bar entry to the interior. In *Untitled #65* (1978), the basket sits on the open rim that defines its hole; its locked top was once the basket's start. Subsequent baskets may have multiple openings, or a few that are eccentrically placed, or none. There might be no defined base or a bottom that must be upended for the meaning of the piece to be clear (*Untitled #182, 1988*).

The linear material that the artist designated for his plaiting and wickerwork ceased to be his sole medium as early as 1977 when he patched together flat segments of bark to create a classic vessel shape (*Untitled #19*). In 1984 he began to mold similar bark around chunks of firewood, creating baskets that combined found object and artifice (*Tree and Its Skin, #112*); now patchwork vied with interlacing as his dominant technique. Plastic rivets first appeared in these constructions in 1987, confusing those who identified his work solely with natural materials and rural nostalgia.

The greatest constant in McQueen's baskets is a thin, light membrane that surrounds space. Not solid, not heavy, not grand, the baskets are shells that divide inner from outer space and allow the artist to ruminate on the qualities of separation and isolation that the baskets possess: Does the basket enfold or exclude? Does it suggest security or entrapment? Can the isolated object, a reductive artifact, address the

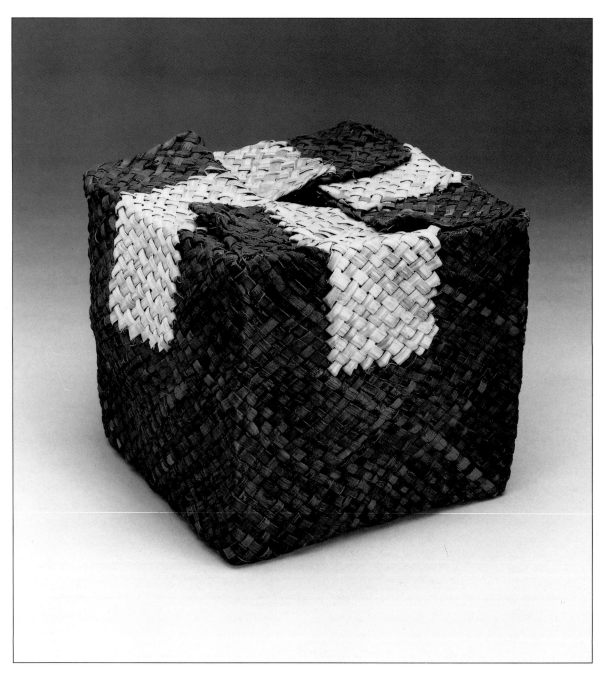

This early basket mimics a cardboard box, complete with tape —
the container of the twentieth century. Unlike its reusable model,
this piece has flaps that cannot be opened without destroying it.
Baskets are shaped when damp; they are locked in their form when dry.
The contents of this container are irretrievable and unknowable.

UNTITLED #7, 1976; basswood and yucca; 8½ × 8½ × 8½ in.

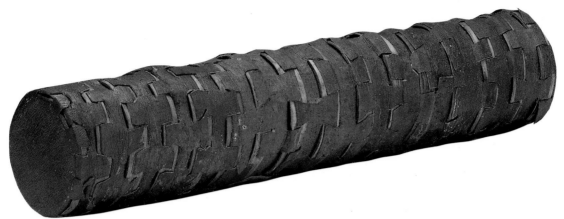

UNTITLED #30, 1977; ash and white pine bark;
6 × 28 × 6 in.

This pipelike form is the opposite of a basket. Its shape, better suited to penetrate than enclose, is masculine rather than feminine.

complex and inclusive natural world? Can the container, a model of concision, also be a model of human thought and language?

Contemplation of such emotional and intellectual questions, rather than definitions, dominate McQueen's journals. These issues are the motivation for baskets that are a form of physical inquiry; they are also the reason for the baskets' variety.

Containment

McQueen's seventh basket mimics a cardboard box with overlapped flaps and white tape (*Untitled #7, 1976*). His model was a commercial artifact, not a treasure found in a museum of fine arts or anthropology. This choice was McQueen's way of declaring that although the ancient art of basketry is his method of expression, he is more interested in the passage of time than in archaeology per se. Basketry for him is a chosen language, not a set of inherited shapes.

The box also indicated McQueen's distance from the world of painters and sculptors. Their realm, he noted in his journal in 1983, is expansive and heroic, while his is contained:

A basket is egocentric and imprisoning, it holds tenaciously to its limits. It has its own organization and regulates its definition closely. By insisting on being a basket, it keeps itself confined. Let other objects try to be art. A basket is isolated, unique, separated from all but itself. Such defenses are tightly held. Uncertainty, movement, fear of being spread out is guarded against. The open object, the object of art leads to a larger reality. The basket must reject this even when inside, it secretly entertains it. These secrets lead to hero worship and flights of fancy. A basket must be careful. In such a state it could become unravelled.[1]

Surely the artist's concentration on issues of security and enclosure reflects his sensitivity to patterns in his own life, in which he fluctuates from periods of severe isolation or contentment and protection within his family to spurts of expansive socializing or energetic creation. The membrane that separates the basket from the nonbasket is the skin that contains the artist's self and divides it from the nonself. The basket, then, is analogous with the artist and his dwelling place.

The French philosopher Gaston Bachelard, whose works are highly valued by McQueen, wrote that "Man is a half-open being. . . . Explore the being of man considered as the being of a surface, of the surface that separates the region of the same from the region of the other."[2]

Explore man, then, as a basket.

Order and Disorder

The human who demands order and exerts control is a small subset of an uncontrolled and unknowable natural world. Nature makes a forest; humans create gardens—small oases of control that must be vigilantly weeded and fenced. For McQueen, making a basket is like creating a garden. It is an exertion of order and control over wild nature for an end that is psychologically, aesthetically, and intellectually nourishing. The basket becomes an agent for investigating the fragile truce between humans and nature.

McQueen's four-part basket, *Untitled #33* (1977), is a clean dissection of a symmetrical form. Cut into equal quarters, the basket is a cube, its center a hemisphere. The exterior is earmarked by the strict checkerboard patterning of plaiting. These attributes announce the ordering mind and controlling

UNTITLED #53, 1978; ash; 18 × 16 × 16 in.

The contours of a classic vessel are created by the chaos of a random weave.

hand—forces of containment. In the basket's interior, the plaiting goes awry. The interlaced jumble, analogous to nature, speaks of abandon, confusion, or mystery rather than control.

A similar bounded random weave is the focus of *Untitled #53* (1978), whose classic profile is achieved through chaotic interlacing. In *Untitled #125* (1985), an ordered vessel is more the victim than the support of a rapacious strangler vine. Humans might desire mastery over nature, but the latter is assured victory. "Trees," McQueen writes on *Silence* (*#228*, 1990), "are only waiting for us to bury ourselves."

Words

Silence is the domain of plants as language is the domain of humans. Given McQueen's focus on distinctions between these domains, the appearance of words on his baskets seems inevitable. Texts on baskets are not simply a consequence of the artist's desire for a contemporary decorative idiom, but the result of his attention to the human self as distinguished from the nonself, in particular from vegetal nature.

In McQueen's first word basket (*Untitled #88*, 1979), the text is not decoration at all, but the structure that binds a frame of forked sticks. The uneven rhythm of poetic calligraphy, unlike the predictable over-and-under pattern of weaving, creates a surface that is difficult, but necessary, to decipher since the contents of this airy basket are the meanings of the words that form its skin; the structure itself has no capacity to hold. The text, like the structure, denies the notion of containment by stating that the future can never be captured: "Always is always a ways away."

The physical basket may be porous, but language is a container of thoughts. It distinguishes the chaotic from the clear, structures the world, and either exposes or conceals—like a basket. Words are as slippery as basket tops and bottoms for McQueen. He conceals them inside or underneath his structures (*Untitled #107*, 1983; *Untitled #182*, 1988); he overlays and mutates them (*Untitled #106*, 1982; *Untitled*

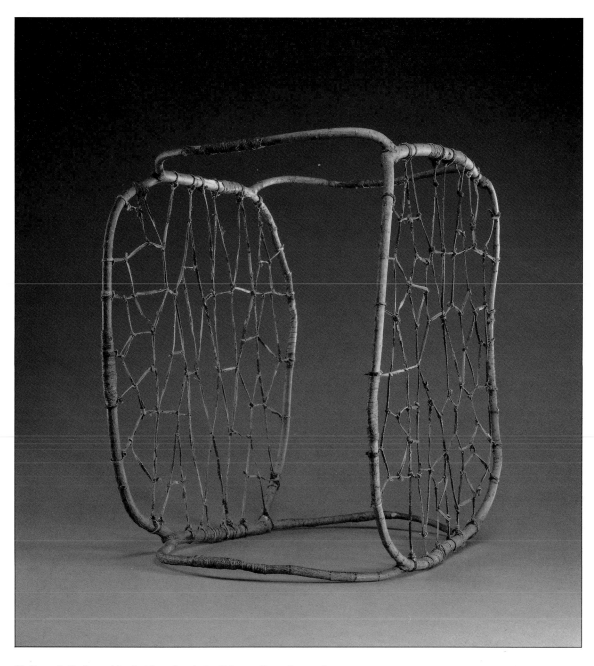

McQueen's first word basket is as insubstantial as calligraphy on air.
The frame is made of forked sticks kept in tension by a written gossamer web.
The meaning of the text—that "always" cannot be captured and contained,
it is forever in the future—coincides with a basket that has no capacity to hold.

Away is not a knot of lost turns
Always is always a ways away

UNTITLED #88, 1979; elm bark and maple; 14 × 15 × 10½ in.

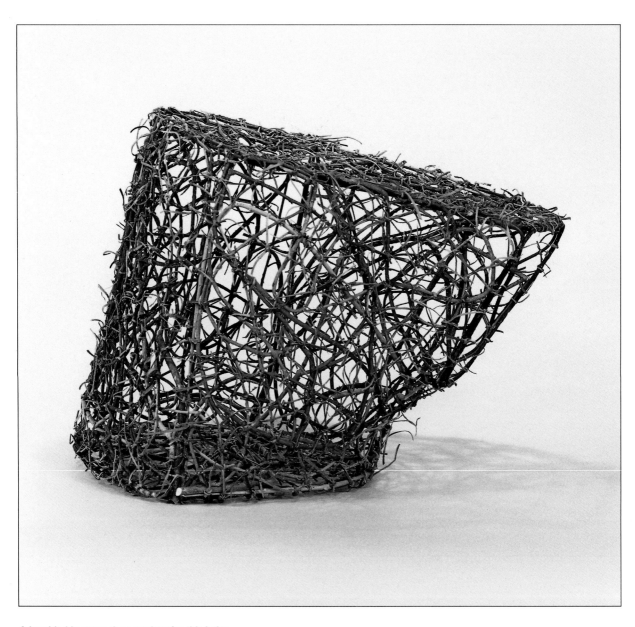

A lopsided log was the template for this hairy,
asymmetric basket, which is both lumbering and weightless.
The side opening is traplike.

UNTITLED #144, 1987; red osier and elm bark; 17 × 17 × 12 in.

#197, 1989). And he plays with sounds and meanings, creating resonant tongue- and mind-twisters ("We keep going without knowing if we are turning or returning," *Untitled #107*, 1983).

Like the concrete poets of the 1960s, McQueen gives words visual punch. "ONCE" circles around a basket, one letter per side, never wholly visible though never entirely gone (*Untitled #165*, 1988). "UNDERSTAND" hides beneath a basket and forms the base it stands on (*Untitled #182*, 1988). The letters *N* and *O* are linked by an interior channel that transforms one letter into the other (*Untitled #197*, 1989). "OUT" tunnels through a column whose contents must be continually ejected (*Untitled #203*, 1989).

Whether words are used for the basket's structure (its stitching, sides, or seams) or its embellishments, they are integral to McQueen's ruminations on containment. Language, like music and dance, unfolds in time. While the artist might try to trap time by locking thoughts to a basket, neither the past nor the future can be held. A poem read aloud is either advancing or retreating; a word once spoken is gone.

McQueen's baskets with words embody the longing to capture time. William Bronk, his favorite poet, wrote in "The World in Time and Space," that we

> *respect the finite shape*
> *of bounded places, as much as to say they are true.*
> *Some absolute of shape is stated there*
> *which satisfies the need that makes this shape.*
>
> *How strange that after all it is rarely space*
> *but time we cling to, unwilling to let it go.*[3]

Trees

In 1984, McQueen took a log from his woodpile and molded a basket around it. The original log, stripped of its bark and punctured by the molding process, was placed next to its hollow replica—core beside membrane. Unlike all previous baskets, McQueen gave this pair a title, *Tree and Its Skin* (*#112*), realiz-

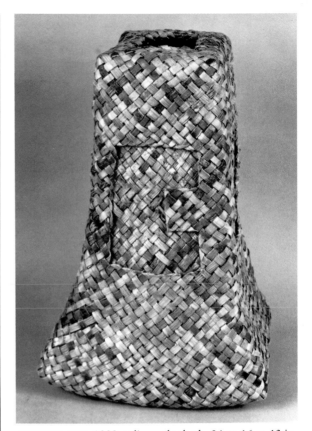

UNTITLED #165, 1988; tulip poplar bark; 24 × 16 × 13 in.

The letters on this basket spell "ONCE," a word that can suggest "formerly," "simultaneously," or "immediately"—conflicting units of time. The word can be read only by circling around the basket; the letters are not visible at once. Yet the word is always present—it has not come and gone like other events that happened once.

ing perhaps that this new way of working deserved a herald.

In using firewood as a mold, McQueen paid direct homage to nature and yielded some of his responsibility as creator to it. He would find the log, discovering fragments of an order, or rather a disorder, that he could not have created on his own. In this case the log resembled a human torso. In using it, McQueen was not saying that trees are equal to humans, but that a quality trees possess distinguishes them from other vegetation; perhaps they have souls.

McQueen accepts that to be human is to use the

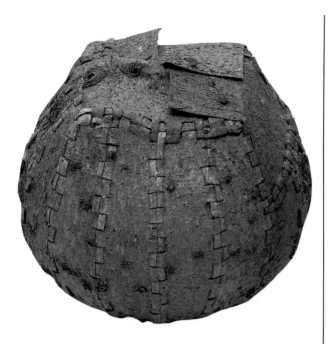

UNTITLED #65, 1978 (reconstructed 1991); spruce bark;
13 × 16 × 16 in.

**Appearing to be a tightly locked form giving no access to its
interior, this basket must be lifted to reveal the hole at its
base. It is a basket to crawl beneath, to use as cover.**

forest: it is the source of the materials for his basketry
as well as his house and his firewood. Yet he is in
awe of the forest's wonders and reveres, as did many
ancient cultures, its sacred attributes. One of these is
the suggestion of immortality in the frequent perse-
verence of bark after the core of a tree has decayed,
the bark remaining as container when all else is gone.
In *Untitled #121* (1985), McQueen places eight hol-
low segments in a tight circle, forming a new ring to
pay homage to the encircling bark that was once each
tree's immortal skin.

In later baskets, McQueen interlaces osier and elm
(*Untitled #144*, 1987), plaits willow around chunks
of firewood (*Untitled #187*, 1989), and continues to
mold and patch bark around trunks and limbs (*Unti-

tled #163*, 1988, and *#189*, 1989). He constructs
each piece so the core can be released from its new,
but temporary, covering. The hollow baskets contain
the memory of the forest. Human definitions of
beauty, often linked to the symmetrical and refined,
are forced to succumb to the unpredictable, even un-
gainly, vigor of trees.

By submitting to nature's design, McQueen relin-
quishes total control and forges a reconciliation be-
tween the self and the nonself. Each of these molded
baskets contains, in its final shape, both the vision of
the artist and an imprint of nature.

In *Just Past Dead Center* (*#232*, 1991), McQueen
plaited brackets, a ledge, and the tree they support,
presenting this ensemble as a hollow basket, a woven
bonsai. This small, singular object, plaited from linear
strips of elm bark, with a bottom and holes at the
top, neatly conforms to all the attributes of a basket
that McQueen listed in 1977.

The title refers to the cambium of a tree, the thin
growing membrane that is sandwiched between the
dead core and bark. This vital layer of growth is like
the basket's surface. The artist—who is carpenter,
gardener, and basketmaker above all else—plaits this
skin, the thin wall between outside and in.

It is human nature to create order in the checker-
board rhythm of plaiting. It is human nature to con-
trol through a radical reduction in scale and assertive
pruning. It is human nature to separate and to be sep-
arate. The cambium of the artist is a frail, energetic
membrane that defines the object, and the human, as
apart from all else.

1 John McQueen, unpublished journal.
2 Gaston Bachelard, *The Poetics of Space* (Boston: Beacon
Press, 1969), p. 222.
3 William Bronk, *Life Support* (San Francisco: North Point
Press, 1981), p. 48.

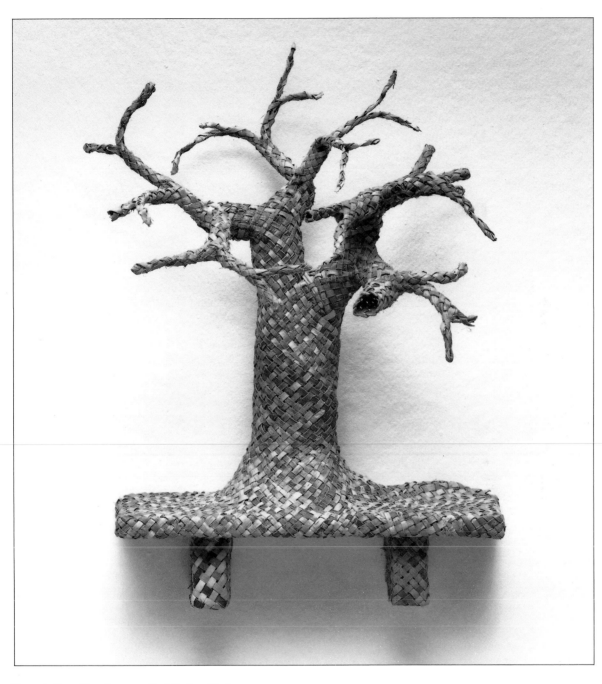

Tree, shelf, and brackets are all plaited and hollow.
Forester and carpenter have succumbed to the artifice of basketmaker.
McQueen notes that the thin cambium layer of a tree is alive and growing; the core
and bark are dead. The plaiting is the artist's cambium—the frail, energetic
membrane that defines the object, and the human, as apart from all else.

JUST PAST DEAD CENTER (#232), 1991; elm bark; 27 × 21 × 13 in.

BIOGRAPHY

Born in 1943 in Oakland, Illinois; lives in Alfred Station, New York.

Education
Florida State University, Tallahassee, 1961–63
University of Indiana, Bloomington, 1964–65
University of South Florida, Tampa, B.A. 1971
Tyler School of Art, Temple University, Philadelphia, M.F.A. 1975

Awards
1988 Artist's Fellowship, New York Foundation for the Arts
1986 Visual Artist Fellowship, National Endowment for the Arts
1980 United States/Japan Friendship Commission Fellowship
1979 Visual Artist Fellowship, National Endowment for the Arts
1977 Visual Artist Fellowship, National Endowment for the Arts

One-Person Exhibitions
1992 Renwick Gallery, National Museum of American Art, Washington, D.C.
1991 Nina Freudenheim Gallery, Buffalo
 Garth Clark Gallery, New York
1990 Garth Clark Gallery, Los Angeles
1989 Garth Clark Gallery, New York
1987 Bellas Artes Gallery, Santa Fe
1986 Nina Freudenheim Gallery, Buffalo
1983 Kansas City Art Institute, Missouri
1980 Greenwood Gallery, Washington, D.C.
 Fiberworks, Center for the Textile Arts, Berkeley, California
1979 Installation, Art Park, Lewiston, New York
1978 Helen Drutt Gallery, Philadelphia
 Foster Gallery, University of Wisconsin, Eau Claire

1977 Hadler/Rodriguez Gallery, New York
 Nina Freudenheim Gallery, Buffalo
 Alliance Gallery, St. Louis
1976 Acadia National Park, Maine, "Art in the Park" commission, National Park Service, Department of the Interior

Selected Group Exhibitions
1991 *Projects Environment,* Ness Gardens, Neston, The Wirral, Cheshire, England
 In Western New York—1991, Albright-Knox Museum, Buffalo, New York
1990 *Meeting Ground: Basketry Traditions and Sculptural Forms,* The Forum, St. Louis (traveling exhibition)
1989 *The Vessel: Studies in Form and Media,* Craft and Folk Art Museum, Los Angeles
 Robert L. Pfannebecker Contemporary American Craft Exhibition, Shippensburg University, Pennsylvania
 Artful Objects: Recent American Crafts, Fort Wayne Museum of Art, Indiana
 Frontiers in Fiber: The Americas, North Dakota Museum of Art, Grand Forks, North Dakota (traveling exhibition)
1988 *Neo Traisjon,* Nordenfjedske Kunstindustrimuseum, Trondheim, Norway
 American Baskets of the Eighties, Chicago Public Library (traveling exhibition)
 Knots and Nets, Herbert F. Johnson Museum, Ithaca, New York (traveling exhibition)
 Basket Masters—Japan and America, Bellas Artes Gallery, Santa Fe
 The Tactile Vessel, Erie Art Museum, Pennsylvania (traveling exhibition)
1987 *Interlacing: The Elemental Fabric,* American Craft Museum, New York (traveling exhibition)
 The Ritual Vessel, Twining Gallery, New York
 The Modern Basket: A Re-Definition, Pittsburgh Center for the Arts
 Baskets from Five Continents, Wadsworth Atheneum, Hartford, Connecticut
1986 *Craft Today, Poetry of the Physical,* American Craft Museum, New York (traveling exhibition; called *Crafts USA* in Europe)
 Tunnel Vision/Frontal Vision (Installation by John McQueen and Jessie Shefrin), John Michael Kohler Arts Center, Sheboygan, Wisconsin
 Material Images: Fifteen Fiber Artists, Bowling Green University, Ohio
 Fibers National Invitational, Edinboro University, Pennsylvania
1985 *Fiber R/Evolution,* Milwaukee Art Museum (traveling exhibition)
 Textile Invitational, Miami University, Oxford, Ohio

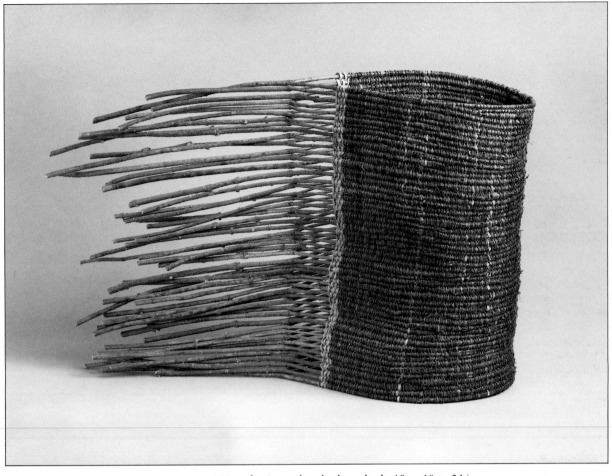

UNTITLED #81, 1979; red osier, walnut bark, and ash; 18 × 10 × 24 in.

A basket with a comet's tail is constructed of sticks whose forked ends are united by weaving. The tail implies direction and movement; the container results from the forced fusion of divergent linear paths into a circular enclosure.

The tension between stasis and motion is explored in a prose poem by John Ashbery that inspired the artist to collect the forked sticks for this basket: *You discovered that there was a fork in the road, so first you followed what seemed to be the less promising, or at any rate the more obvious, of the two branches. . . . Then you returned to investigate the more tangled way. . . . You began to realize that the two branches were joined together again, farther ahead; that this place of joining was indeed the end, and that it was the very place you set out from, whose intolerable mixture of reality and fantasy had started you on the road which has now come full circle.* "The System" (from *Three Poems,* New York, 1972)

1981 *The Art Fabric: Mainstream,* San Francisco Museum of Modern Art (traveling exhibition)
Twenty-fifth Anniversary Exhibition, Museum of Contemporary Crafts, New York
1980 *The Contemporary Basketmaker,* Purdue University, West Lafayette, Indiana
Art for Use, Center for Music, Drama, and Art, Lake Placid, New York
1979 *Twentieth Century Design,* Recent Acquisitions, Philadelphia Museum of Art
Ferne Jacobs/John McQueen, Clay and Fiber Gallery, Taos, New Mexico
Five in Fiber, Virginia Commonwealth University, Richmond
Fiber Structures and Fabric Surfaces, Herron School of Art, Indianapolis, Indiana
1978 *Baskets—An Exhibition of Contemporary Baskets in All Media,* Meier Brier Weiss Gallery, San Francisco
Louis Knauss/John McQueen, The Hadler Galleries, Houston
Jessie Shefrin/John McQueen, University of North Dakota, Grand Forks
1977 *Fiberwork of the Americas and Japan,* National Museum of Art, Kyoto, Japan
American Crafts '77, Philadelphia Museum of Art
Clay, Fiber, Metal, Skidmore College, Saratoga Springs, New York
Jessie Shefrin/John McQueen, Houghton College, New York
Fiber Invitational, Rhode Island School of Design, Providence

The Art of Basketry, Florence Duhl Gallery, New York
Wicker, Reeds, Grasses—An Exhibition, Danbury Public Library, Connecticut
Artistry: Clay and Fiber, Sarah Lawrence College, Bronxville, New York
1976 *National Invitation Basketry Exhibition,* Cypress College, Cypress, California
Shefrin/Higby/McQueen, Alfred University, New York
Finger Lakes Art Exhibition, Memorial Art Gallery, Rochester, New York
1975 *Objects: Basketry Techniques,* American Craftsman Gallery, New York
Inaugural Exhibition, The Hadler Galleries, New York
Marietta College Craft National, Ohio
1974 *Annual Drawing and Sculpture Show,* Del Mar College, Corpus Christi, Texas
1973 *Annual Exhibition of Contemporary Crafts,* Delaware Art Museum, Wilmington

Collections
Albuquerque Art Museum, New Mexico
Cooper-Hewitt Museum, Smithsonian Institution, New York
Detroit Institute of Art
Erie Art Museum, Pennsylvania
Herbert F. Johnson Museum of Art, Ithaca, New York
Kunstindustrimuseum, Trondheim, Norway
Minneapolis Institute of Art
Philadelphia Museum of Art
Renwick Gallery, National Museum of American Art, Smithsonian Institution, Washington, D.C.
Seattle Art Museum
Wadsworth Atheneum, Hartford, Connecticut

SELECT BIBLIOGRAPHY

Books and Catalogues

Constantine, Mildred, and Laurel Reuter. *Frontiers in Fiber: The Americans.* Grand Forks, N.D.: The North Dakota Museum of Art and the United States Information Agency, 1988.

Diamonstein, Barbaralee. *Handmade in America: Conversations with Fourteen Craftmasters.* New York: Harry N. Abrams, 1983.

LaVilla-Havelin, Lucia. *The New Basket: A Vessel for the Future.* Potsdam, N.Y.: State University of New York, 1984.

Hynes, Bill, ed. *Craft Symposium and Robert L. Pfannebecker Contemporary American Craft Exhibition.* Shippensburg, Penn.: Shippensburg University, 1989.

Larsen, Jack Lenor, and Mildred Constantine. *The Art Fabric—Mainstream.* New York: Van Nostrand Reinhold, 1981.

Larsen, Jack Lenor, and Betty Freudenheim, eds. *Interlacing: The Elemental Fabric.* Tokyo: Kodansha International, 1986.

Larsen, Jack Lenor, *The Tactile Vessel,* Erie, Penn.: Erie Art Museum, 1988.

Manhart, Marcia, and Tom Manhart, eds. *The Eloquent Object.* Tulsa, Okla.: Philbrook Museum of Art, 1987.

Opstad, J. L., ed. *Neo Tradisjon.* Trondheim, Norway: Nordenfjeldske Kunstindustrimuseum, 1988.

Press, N. N. *Knots and Nets.* Ithaca, N.Y.: Cornell University, 1988.

Pulleyn, Rob, ed. *The Basketmaker's Art.* Asheville, N.C.: Lark Books, 1986.

Shermeta, Margo. *American Baskets of the Eighties.* Chicago Public Library, 1988.

———. *Meeting Ground: Basketry, Traditions and Sculptural Forms.* Tempe, Ariz.: Arizona State University, 1990.

Periodicals

Bell, David. "McQueen's Work Constitutes a Genre of Its Own." *Journal North* (Sante Fe), 1 June 1989.

Freudenheim, Betty. "Can Knots and Netting Be Art?" *New York Times,* 3 December 1989.

———. "Basketry Becomes a Showcase Craft." *New York Times,* 8 October 1987.

Geibel, Victoria. "The Evolving Basket." *Metropolis* (June 1989).

Hammel, Lisa. "A Passel of Baskets." *Town and Country* (August 1988).

Huntington, Richard. "Master Craftsmen Show Is an Awesome Display of Technical Ability." *Buffalo News,* 2 December 1988.

Jepson, Barbara. "Gallery, Form and Fiber." *Wall Street Journal,* 1 May 1987.

Kline, Katy. "McQueen's Baskets Called Individual, Compelling." *Buffalo Courier-Express,* 18 December 1977.

Koplos, Jan. "When Is Fiber Art 'Art'?" *Fiberarts* (March/April 1986).

Lebow, Edward. "John McQueen, Bellas Artes." *American Craft* (October 1987).

Malarcher, Patricia. "What Is a Basket?" *Fiberarts* (January/February 1984).

———. "A Basket Is. . . ." *American Craft* (February 1990).

Margetts, Martina. "Crafts in America." *Crafts Magazine* (Great Britain) (March/April 1982).

———. "Other Baskets: An Invitational Show in St. Louis." *Fiberarts* (January/February 1983).

McQueen, John. "Poetry in the Round." *Surface Design* (Spring 1989).

Park, Betty. "The Basket Redefined." *American Craft* (October 1979).

———. "John McQueen: An Interview." *Fiberarts* (January/February 1979).

Peters, Susan Dodge. "Basket Art." *Democrat and Chronicle* (Rochester, New York), 21 October 1984.

Sax, George. "McQueen Is Traditional in His Approach." *The Buffalo News,* 28 October 1986.

Shermeta, Margo. "The Basket, The Mark, The Tree." *Fiberarts* (January/February 1991).

———. "John McQueen: Basketmaker of Mixed Messages." *Art Spaces* (January 1991).

CHECKLIST

Spiral, 1975 (not shown)
Wool and burdock (burrs)
8 × 12 × 8 in.
Dorothy C. Miller

Untitled #7, 1976 (page 42)
Basswood bark and yucca leaves
8½ × 8½ × 8½ in.
Vincent Tovell

Untitled #11, 1976 (page 17)
Morning glory vines and day lily leaves
11 × 13 × 14 in.
Florence Duhl

Untitled #13, 1976 (page 17)
Basswood bark
7 × 12 × 12 in.
Robert L. Pfannebecker

Untitled #16, 1976 (page 18)
White pine bark
17 × 10 × 10 in.
William Atlee, Jr.

Untitled #19, 1977 (page 25)
White pine bark
24 × 15 × 15 in.
Karen Johnson Boyd

Untitled #25, 1977 (page 26)
Malaluka bark, milkweed, and Spanish moss
15 × 10 × 10 in.
Robert L. Pfannebecker

Untitled #30, 1977 (page 43)
Ash and white pine bark
6 × 28 × 6 in.
John McQueen

Untitled #33, 1977 (page 18)
Basswood bark
10 × 16 × 16 in.
Ricky Leff Warwick

Untitled #53, 1978 (page 44)
Ash
18 × 16 × 16 in.
Marion Boulton Stroud;
promised gift to the
Philadelphia Museum of Art

Untitled #65, 1978 (reconstructed 1991) (page 48)
Spruce bark
13 × 16 × 16 in.
Helen Williams Drutt English

Untitled #69, 1979 (page 55)
Spruce bark
12 × 9 × 9 in.
Robert L. Pfannebecker

Untitled #80, 1979 (page 27)
White pine bark, tulip poplar bark, ash bark and ink
12 × 16 × 16 in.
Robert L. Pfannebecker

Untitled #81, 1979 (page 51)
Red osier, walnut bark, and ash
18 × 10 × 24 in.
Private collection

Untitled #88, 1979 (page 45)
Elm bark and maple
14 × 15 × 10½ in.
Robert L. Pfannebecker

Untitled #89, 1979 (page 22)
Spruce roots
8½ × 13 × 13½ in.
Mrs. Robert L. McNeil

Untitled #94, 1980 (page 5)
Cedar bark and ash
21¼ × 10 × 10 in.
Elsa and Julian Waller

Untitled #106, 1982 (page 28)
Red osier, willow and elm bark
16 × 12 × 12 in.
Vincent Tovell

Untitled #107, 1983 (page 29)
Ash and string
18 × 9 × 9 in.
Gerhardt Knodel

Untitled #110, 1983 (not shown)
Mixed wood
12 × 18 × 18 in.
Kathy and Jeffrey Friedland

Tree and Its Skin (#112), 1984
(page 30)
White pine bark, walnut bark, and ash
18 × 9 × 10 in. each (2 pieces)
Pat and Judy Coady

Untitled #121, 1985 (page 31)
White pine bark and ash
16 × 40 × 40 in. overall (8 pieces)
Renwick Gallery, National Museum of American Art, Smithsonian Institution
Museum purchase made possible by Mrs. Marshall Langhorne, 1988.55

Untitled #125, 1985 (page 34)
Ash, grapevine, and mud
18 × 18 × 18 in.
Carol A. Straus

Untitled #140, 1986 (page 12)
White pine bark and mixed wood
21 × 27 × 16 in.
Pat and Judy Coady

Untitled #142, 1986 (not shown)
Mixed wood
13 × 24 × 18 in.
Neutrogena Corporation

Untitled #144, 1987 (page 46)
Red osier and elm bark
17 × 17 × 12 in.
Pamela and David Banks

Untitled #150, 1987 (page 8)
Willow bark
18 × 18 × 12 in.
Robert L. Pfannebecker

Untitled #163, 1988 (page 32)
Tulip poplar bark and plastic rivets
29 × 17 × 12 in.
Jim Harris

Untitled #165, 1988 (page 47)
Tulip poplar bark
24 × 16 × 13 in.
Mr. and Mrs. Larry Magid

Untitled #176, 1988 (page 35)
Ash bark
12 × 19 × 19 in.
Mr. and Mrs. Sanford M. Besser

Untitled #182, 1988 (page 23)
Elm bark
16 × 22 × 16 in.
Gerald and Sondra Eskin

Untitled #183, 1988 (page 33)
Goldenrod
22 × 44 × 44 in.
Robert and Nina Freudenheim

Untitled #187, 1989 (page 36)
Willow bark
16 × 22 × 18 in.
Emily Fisher Landau

Untitled #189, 1989 (page 37)
Spruce bark and plastic rivets
15 × 32 × 13 in.
Seattle Art Museum
Gift of Marion Boulton Stroud, 91.82

Untitled #192,* 1989 (page 38)
Burdock (burrs) and applewood
23 × 19 × 20 in.
Bellas Artes, Santa Fe
*(not in exhibition)

Untitled #197, 1989 (page 2)
Spruce bark
20 × 24 × 9 in.
Mr. and Mrs. Sanford M. Besser

Untitled #202, 1989 (page 19)
Willow bark
26 × 20 × 10 in.
Robert L. Pfannebecker

Untitled #203, 1989 (page 39)
Tulip poplar bark
31 × 12 × 12 in.
Mrs. Oscar Feldman

OurbOurOs (#214), 1990 (not shown)
Spruce bark, pine bark, poplar bark,
and plastic rivets
16 × 24 × 23 in.
John McQueen; courtesy of Nina
Freudenheim Gallery

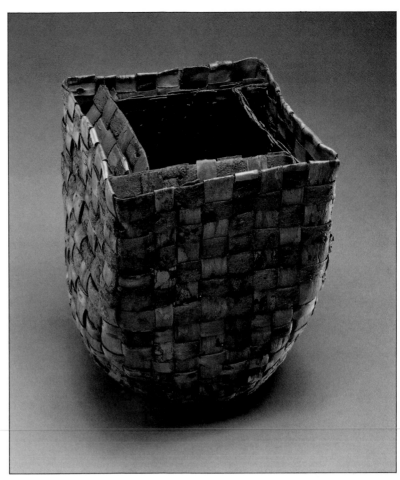

UNTITLED #69, 1979; spruce bark; 12 × 9 × 9 in.

**Here is a basket with two insides—the
simple exterior hides a second inside
wall. The emergence of this second
skin midway up the basket's interior
is as inexplicable as the square neck
rising from a round base.**

Untitled #215, 1990 (page 19)
Elm bark
17 × 25 × 23 in.
John McQueen; courtesy of Garth
Clark Gallery

Knot Hole Spruce Skin (#220), 1990
(page 21)
Spruce bark, orange peel, and plastic
rivets
15 × 22 × 18 in.
Joan N. Borinstein

Silence (#228), 1990 (page 40)
Spruce bark, string, and plastic rivets
27 × 10 × 10 in.
Private collection

Just Past Dead Center (#232), 1991
(page 49)
Elm bark
27 × 21 × 13 in.
John McQueen; courtesy of
 Nina Freudenheim Gallery